IMAGES
of America

MALVERN

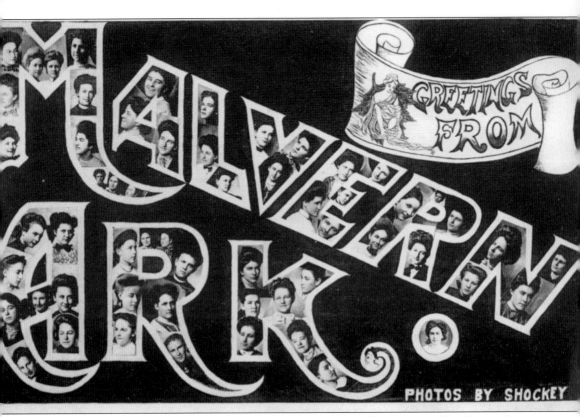

Local Malvern photographer Phillip C. Shockey created this collage of young Hot Spring County women to promote the charms of the city around 1908. Shockey and his camera were prominent in the first decade of the 20th century, helping record images that endure a century later.

ON THE COVER: The cover photograph, of the Bright Spot Café, dates from around 1940. In business for more than 20 years, the Main Street establishment served up a menu ranging from hamburgers to ice cream and popcorn. The popcorn machine sat in the front entrance, drawing children's attention as they shopped with their mothers. The café was especially popular during the 1940s with its dance hall on the second floor. The building remains, but the business has been gone for decades.

IMAGES
of America

MALVERN

Steven Hanley and Ray Hanley

ARCADIA
PUBLISHING

Published by Arcadia Publishing
Charleston, South Carolina

Printed in the United States of America

Library of Congress Control Number: 2010923099

For all general information, please contact Arcadia Publishing:
Telephone 843-853-2070
Fax 843-853-0044
E-mail sales@arcadiapublishing.com
For customer service and orders:
Toll-Free 1-888-313-2665

Visit us on the Internet at www.arcadiapublishing.com

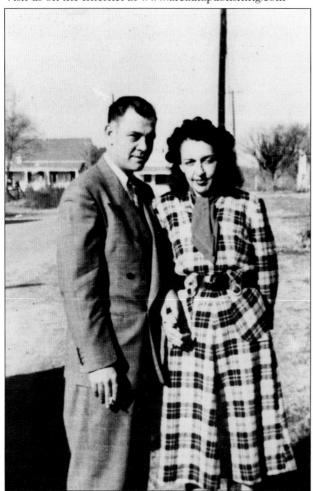

This photograph shows our parents, Wallace Ray Hanley (1909–1974) and Inez Marie Hanley (1921–1988), on Baker Street in Malvern, around 1944. The authors dedicate this history of our hometown to our parents, lifelong residents of Malvern.

CONTENTS

ACKNOWLEDGMENTS

This book is made possible with the support and input of members of the Malvern community committed to the preservation of the history of their hometown. Special thanks go to Janis West at the Hot Springs County Museum Commission; members of the Hot Spring County Historical Society, including Flora Rondeau who gave us open access to the society's photograph archives; Kinney Black; Mr. and Mrs. Homer Lawrence; Shirley Henry; Pauline Reynolds; Donna Langston; Marty Nix of the Ritz Theater; James and Carolyn Batts; LeMay Photography of Little Rock; and the staffs of the Hot Springs County Library and of the Butler Center for Arkansas Studies in Little Rock.

Much of the rich history of Hot Spring County and its seat of Malvern, dating back into the 1800s, could have easily been lost to present and future generations without the dedication of the Hot Spring County Historical Society. The charter members were photographed in 1967 and include, from left to right, (first row) Nancy Rutherford, Eudora Fields, Mrs. Grady Cullins, Mrs. Frank Cline, and Mrs. Gerald McClane; (second row, beginning third from left) Rev. Mac Gates, Judge Neal Phelan, Joe McCoy, Judge William Gilliam, Jack McCoy, and Grady Cullins. The two men farthest left in the second row were David Whittington of Hot Springs and John Ferguson, the Arkansas state historian.

Unless otherwise noted, photographs in the book come from the authors' personal collections.

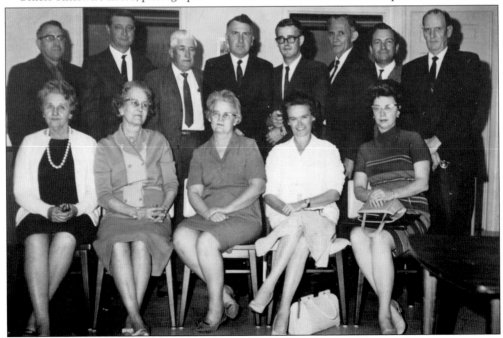

FOREWORD

Steven and Ray Hanley were raised in Malvern, products of the community and graduates of Malvern High School. They have taken their love of history and nostalgia for the past and preserved it in a delightful way. By using their collection of postcards, photography, and historical stories, they bring history alive.

As the director of educational school tours at the Hot Spring County Museum in Malvern, my goal is bringing history alive for the students. I look forward to introducing the students to the publications of the Hanley brothers. I am most excited about this publication, Images of America: *Malvern*. It has been said history is a treasured gift not to be kept to ourselves. Thank you, Ray and Steven, for sharing Malvern's history. The HSCM Commission is dedicated to the preservation of history for the present and future generations, in memory and appreciation of past generations. This is truly a gift because today's students learn best visually.

There is a great need in today's society for our children and youth to know their past. Fewer and fewer pass down family history. Our museum works to blend community history and family history. Teaching where we have been brings light to today's world. Taking a trip back in time through Steven and Ray's publications will teach the young and give older generations time to reminisce.

—Janis West, chairperson
Hot Spring County Museum Commission

INTRODUCTION

Hot Spring County was established by the Arkansas Territorial Legislature in November 1829 from part of Clark County. Ironically the hot spring for which the county was named is no longer within the county limits. Garland County was created in 1873 in response to complaints from the City of Hot Springs about the difficult trek to the county seat, which was then located at Rockport. As a result, the City of Hot Springs and the springs themselves (except for one near Magnet Cove) are no longer located in Hot Spring County.

Malvern was established in 1873 as a station on the Cairo and Fulton Railroad. The area's hilly terrain is said to have reminded one railway official of the countryside around his hometown of Malvern Hill, Virginia. Growing rapidly, Malvern was incorporated in July 1876, and Samuel Emerson, owner of its first dry goods store, was elected mayor. In October 1878, five years after its creation, Malvern became the county seat. Thanks to its rail access to national markets, agriculture and timber production thrived. By 1890, Malvern had over 1,500 residents.

The area's abundant clay deposits gave rise to Malvern's premier industry, the production of bricks. Atchison Brick Company began operation in the 1890s. When most of its downtown was destroyed by fire in the late 1890s, the city rebuilt the business district with all-brick structures. Arkansas Brick and Tile (ABT) gained control of the Atchison facilities in 1917. Acme Brick Company purchased property in nearby Perla in 1919 and shipped the first bricks from its Perla plant two years later. In 1926, Acme took over the ABT operations. By 1929, Acme had plants operating at Perla and Malvern. Today Malvern bills itself as the "Brick Capitol of the World."

Malvern was working to shake off the Great Depression when Pres. Franklin D. Roosevelt and the first lady visited Arkansas on June 10, 1936. Their one-day visit marked the opening of the state's centennial celebration. That afternoon, the first couple drove from Lake Catherine to attend a historical pageant and an outdoor worship service at the Rockport Methodist Church. Afterwards they led a parade down Malvern's Main Street before boarding their train for Little Rock. An estimated 10,000 people, the largest crowd in the history of Hot Spring County, turned out for the historic day.

World War II would see many local men off to fight, as global conflict put changes into motion that would affect the local economy for decades. The war brought an unprecedented demand for the barite found in Hot Spring County. The mineral was used in oil-well drilling. Demand for aluminum also prompted the federal government to construct a massive reduction plant at Jones Mill. The Reynolds Company purchased the Jones Mill facility after the war and operated it until the 1980s.

In recent years, Malvern's economy has benefited from the creation of Ouachita Technical College in 1991 and the opening of a unit of the state prison in 2003. The timber industry continues to be a vital industry, with much of the land being owned by large companies. Looking ahead, the City of Malvern hopes to attract new industry, draw retirees looking for a small town way of life not far from the big city of Little Rock, and develop attractions like a white-water park on the Ouachita River. While looking forward to Malvern's future, we hope our readers enjoy looking backwards at the history of the city and Hot Spring County.

One

RIVER AND RAIL

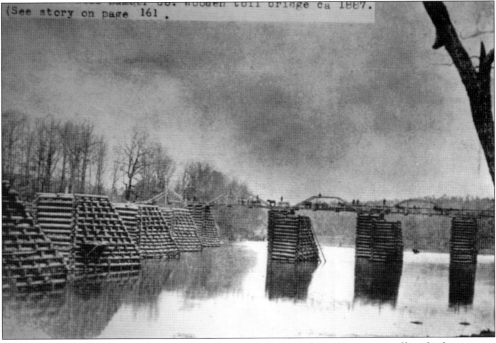

The pioneers of Hot Spring County were drawn to the Ouachita River originally, which gave rise to the first county seat of Rockport. A decade after the Civil War, however, it was the coming of the railroad that took the seat of the county to the nearby town of Malvern and provided the means for a booming timber and manufacturing town to develop. The first river bridge built in Arkansas was a wooden toll bridge over the Ouachita River at Rockport in 1846; it was destroyed by flooding the following year. The private wooden toll bridge in this photograph was constructed in 1887. The tolls were 5¢ to walk; a horse and rider were 15¢; a four-horse team cost 75¢; cattle could cross for 5¢ a head; and sheep, goats, or hogs for 2.5¢ each. (Courtesy HSC Historical Society.)

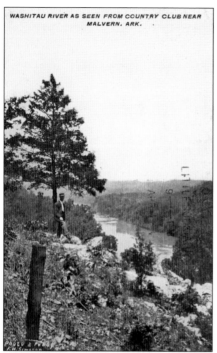

WASHITAU RIVER AS SEEN FROM COUNTRY CLUB NEAR MALVERN, ARK.

According to the caption, this view of the Ouachita River was taken from the community's country club. Mailed to Little Rock in 1911, the message reads, "Coming to have a long talk with you soon. Want information, advice and maybe sympathy. Suppose you were shocked by the earthquake. Just a few of us country people knew anything about it here. Do you ever see Miss Joe? Kindest regards." Note the unusual but incorrect spelling of the river's name in the caption.

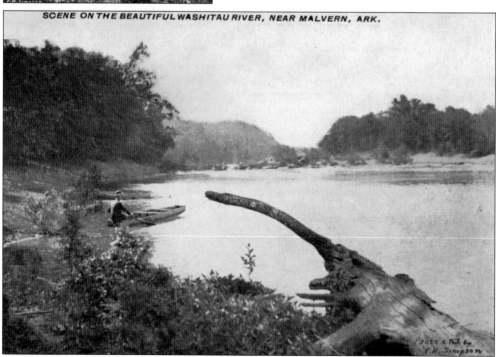

SCENE ON THE BEAUTIFUL WASHITAU RIVER, NEAR MALVERN, ARK.

This picture was taken around 1909. The Ouachita River originates in the Ouachita Mountains of Polk County in west-central Arkansas near the Arkansas-Oklahoma border and flows 600 miles before joining the Black and Red Rivers in north-central Louisiana. It winds through 11 Arkansas counties and five Louisiana parishes. Today the Ouachita River is noted for its great fishing, especially bass and bream.

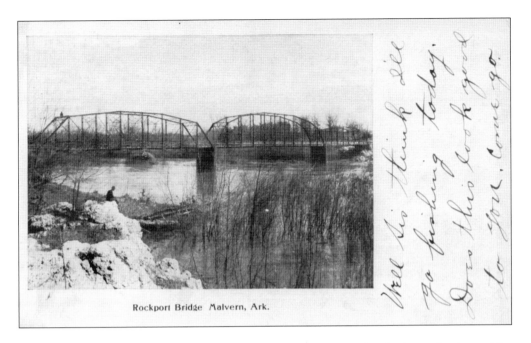

Rockport Bridge Malvern, Ark.

In October 1899, Hot Spring County levied a tax to build a new free bridge at Rockport. The postcard above showing a lone fisherman, mailed in 1908, carried the message, "Think I'll go fishing today. Does this look good to you? come go. The weather is spring today and flowers are in bloom. I am going to see Ben Huss in Little Rock tonight." The bridge had been made possible by the contract awarded to Stupp Brothers Bridge and Iron Company of St. Louis for a bid of $26,000 in April 1900. Two hundred people attended the dedication of the new structure on November 8, 1900. As the years rolled by, many other groups gathered on and under the bridge, including an Arkansas state militia unit on maneuvers posed on the bridge below in 1908.

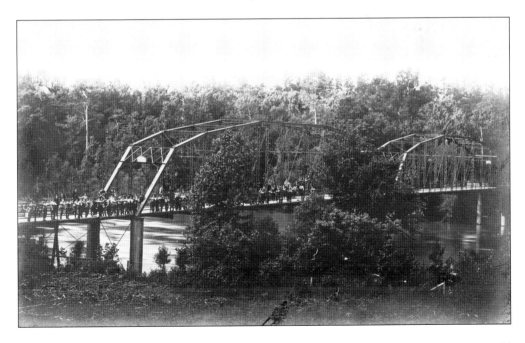

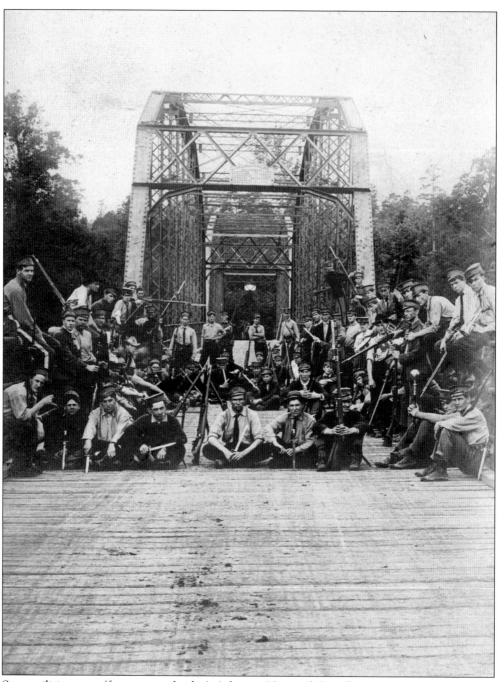

State militia troops (forerunner of today's Arkansas National Guard) were on a training exercise near the Rockport Bridge in May 1908. Then as now, most of these men had full-time civilian careers. Conducting their military training as "weekend warriors," they were often called out by the governor in the aftermath of tornados, floods, or civil disorders. The Arkansas National Guard and its militia predecessor have furnished troops for every war the United States has fought since the early 1800s with the exception of Vietnam, when few National Guard units were called to active duty.

For several years after the Rockport Bridge's construction, its approach consisted of a rough, steep wagon road. The state militia that had posed on the bridge earlier had some hiking to do to return from their bridge visit.

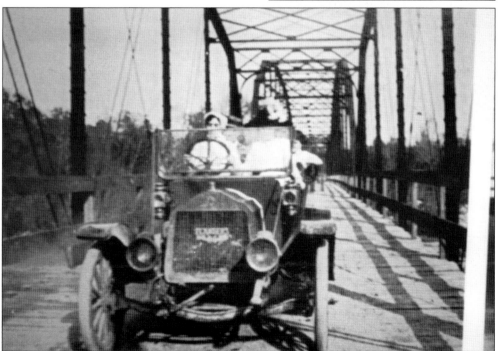

By the time of this *c.* 1910 photograph, the Rockport Bridge was a popular local gathering place. This family posed in their "Tin Lizzie." When debris from flash flooding seriously damaged the structure's piers in February 1987, it was closed to traffic.

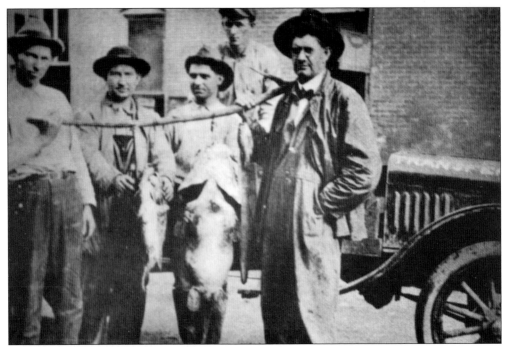

The free-flowing Ouachita River, its banks crowned with dense forest, was a fisherman's paradise in the early years of the 20th century. Around 1921, a giant catfish pulled from the river was brought into downtown Malvern, shown off by, from left to right, Bob Erwin, Nat Erwin, Ples Erwin, Ollie Griggs, and W. C. Vickery. (Courtesy HSC Historical Society.)

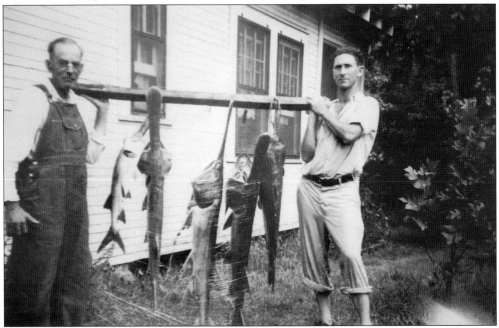

The coming of Remmel Dam, forming Lake Catherine, changed the nature of the once free-flowing Ouachita. Below the dam one day in the 1940s, James Eber Coston and Floyd McQueen displayed a catch of shovel-billed catfish. (Courtesy James and Carolyn Batson of Malvern.)

14

Harvey Couch, the founder of Arkansas Power and Light, built the first hydroelectric dam on the Ouachita River between Hot Springs and Malvern. An engineering marvel in its day, Remmel Dam was named in honor of army colonel Harmon L. Remmel.

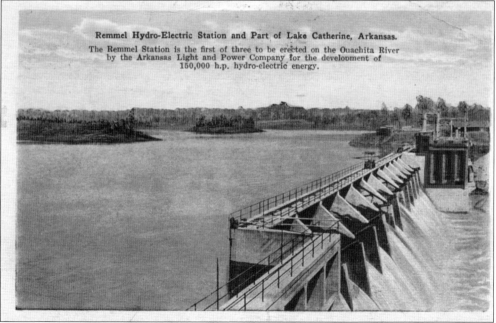

Remmel Hydro-Electric Station and Part of Lake Catherine, Arkansas.
The Remmel Station is the first of three to be erected on the Ouachita River by the Arkansas Light and Power Company for the development of 150,000 h.p. hydro-electric energy.

Remmel Dam was completed in 1924, forming Lake Catherine, which Harvey Couch named for his daughter. The dam brought dependable electricity to Malvern and Hot Spring County. Couch built a rustic log cabin on Lake Catherine, which he named Couchwood. Over the years, he entertained guests ranging from childhood friends and fellow industrialists to Hollywood stars and U.S. presidents.

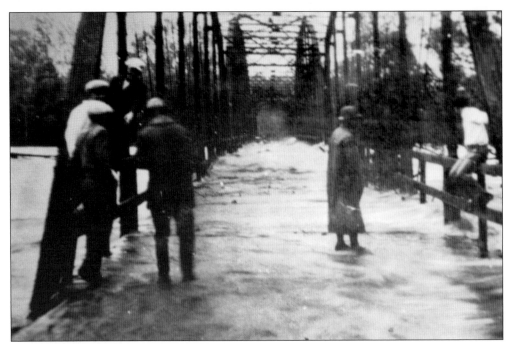

Despite the Remmel Dam a few miles upstream, the Rockport Bridge would still feel the stress of floodwaters that sometimes rose above the bed of the bridge, as in this c. 1930 photograph. That it survived many floods was a testament to the engineering that went into its design and construction.

The aging bridge was closed to vehicle traffic in 1987 after a flood determinedly and seriously damaged the underpinnings, making it unsafe for motorists. Local citizens, hopeful of repairs, would lose the landmark in 1990 when a massive flood swept the bridge away.

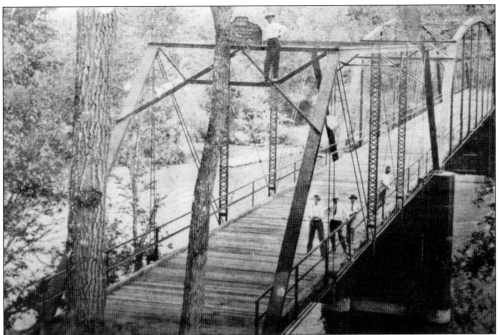

A landmark for 90 years, the 526-foot bridge was gone, but two pieces of the historic structure had been saved. In the c. 1900 photograph above, not long after the bridge was finished, one of the five men posed on the structure and is shown standing atop the entrance by an iron plaque. Present on both ends of the span, the plaque told approaching traffic (horses and wagons when first opened) that it had been built by the Stupp Brothers Bridge and Iron Works of St. Louis. The bridge commissioners, mostly local elected officials, got their names on the signs. Fearful that the next flood would finish the already damaged and closed bridge, officials removed the plaques. Today both are displayed at the Hot Spring County Museum, as seen below.

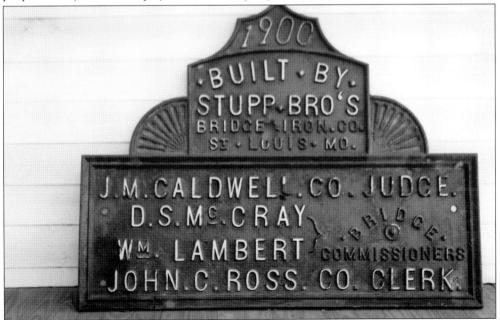

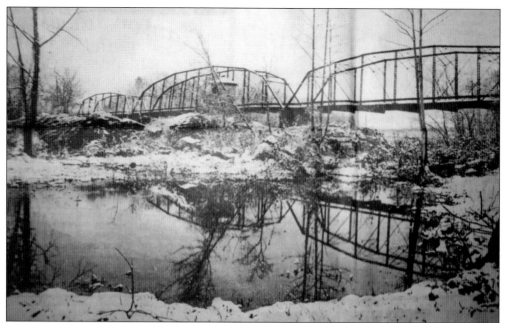

The bridge was gone but in some ways remained. Certainly it remained in the memories of generations of residents who had walked or driven wagons, cars, or trucks over it. Memories of picnics and swimming beneath the bridge, listening to the unmistakable rattle of cars passing over the wooden planks of the bridge far overhead, remained in people's minds. Sadly the replacement concrete-span, modern bridge would not hold the same allure or catch the changing seasons in such ways as the Rockport Bridge did above after a snowfall long ago. One thing that does remain today, though, is the river that flowed beneath the bridge for most of a century. The 1910 postcard showed the Ouachita "falls" just upstream from the iron bridge. Today the site is a designated white-water park for kayakers and canoeists.

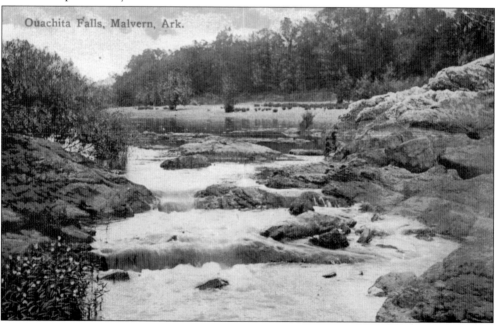

Ouachita Falls, Malvern, Ark.

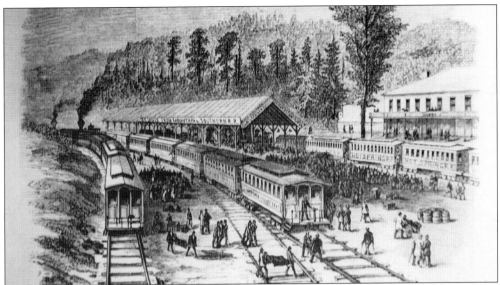

In 1873, the St. Louis, Iron Mountain, and Southern Railroad Company laid out the town of Malvern alongside the tracks it had laid through Hot Spring County. Growth came slowly but accelerated two years later, when wealthy northern businessman "Diamond Joe" Reynolds put in a narrow-gauge rail line between the Malvern junction station and the developing resort of Hot Springs some 25 miles away. The aged and infirmed no longer had to transfer to a stagecoach at Malvern, but rather to the well-appointed railcars of Reynolds, to complete the journey to the spa for what they hoped would be a health-restoring treatment in the thermal waters.

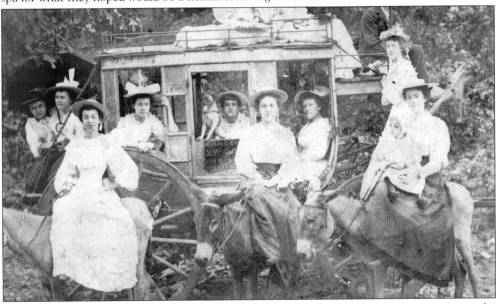

When the "Diamond Joe" railroad linked the Malvern junction with Hot Springs, it put the stagecoach line out of business, allowing spa health seekers to finish the trip in comfort without the need to transfer to the rough, horse-drawn ride over the final 20 miles. Robbers, rumored to be the gang of Jesse James, hit the stage and its passengers on at least one occasion. "Robbed by Jesse James" is marked in chalk at the top of the stage. It was photographed here years later as a prop by a Hot Springs photographer. (Courtesy Donna Langston of Malvern.)

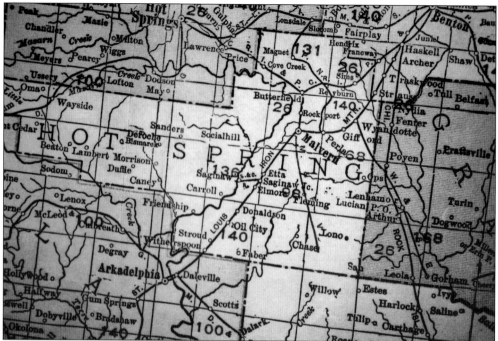

By 1890, the railroad had become the lifeblood of Hot Spring County commerce as seen on this map. Lines came in from both Benton to the north and from Hot Springs to the west with Hot Spring county stops at Malvern and smaller places like Gifford, Donaldson, Oil City, Perla, and Rockport. There was even a spur line from Saginaw Junction to Saginaw located on the Ouachita River.

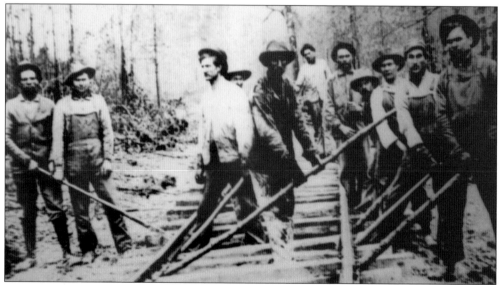

The work of laying the tracks through what had been wilderness a few short years earlier was backbreaking labor, but many men in Hot Spring County and beyond took the work to earn a living. The crew seen here around 1880 was using iron bars to leverage the rails into place on the heavy cross ties; in combination with spikes, these would be used to fasten the new path of the "iron horse" into place. (Courtesy HSC Historical Society.)

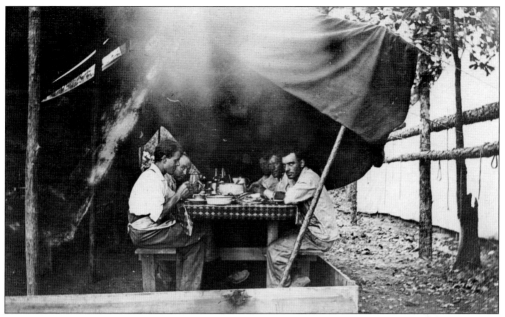

The railroads sometimes hired construction companies that specialized in laying rails to bring in crews skilled in the hard work. Such was the case near Malvern with the C. E. Adams Company from Marianna, Arkansas. The crew is seen here in their mess tent having dinner after a hard day of labor.

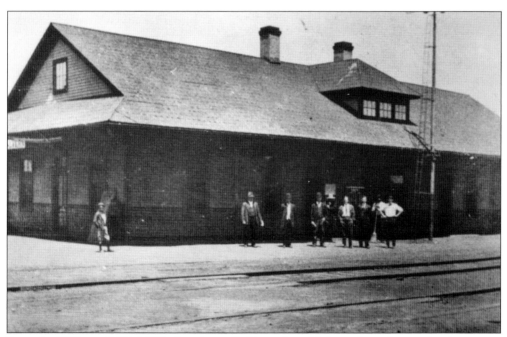

From the 1890s until World War I, trains pulled in and out Malvern from the wooden depot seen above. The enlarged depot handled several passenger trains a day and provided a shipping point for goods to stock Main Street merchants located up the hill. (Courtesy HSC Historical Society.)

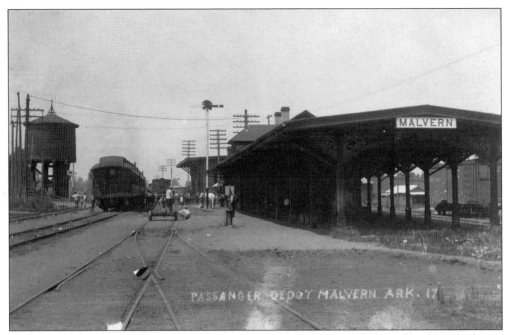

This photograph captured a view of the depot looking east toward the covered loading platforms. To the left, a train has recently pulled into the depot just ahead of a hand-powered cart on the inside track.

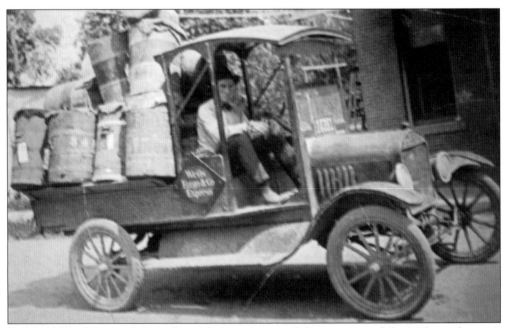

By World War I, automobile traffic was starting to crowd the area around the Malvern depot. A frequent sight was the Wells Fargo truck driven by John Calvin Gibbs, who was usually there to meet the trains, drop off freight to be shipped, or pick up consignments coming off the trains. (Courtesy HSC Historical Society.)

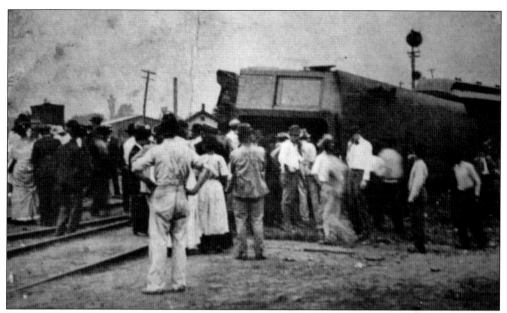

Train traffic was bringing the world to Malvern, but it was not always without tragedy. On October 11, 1911, the crowded train was pulling out of the station bound for Hot Springs, which at the time hosted the Arkansas State Fair, when an improperly placed switch on the track caused the train to leave the rails near the depot, drawing hundreds of people from town. Nellie Fowler Kilpatrick was seriously injured and died some 30 minutes after the accident.

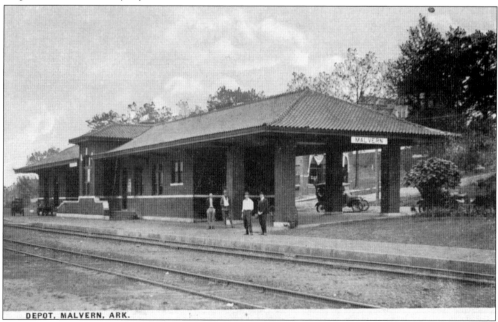

DEPOT, MALVERN, ARK.

By 1928, when this postcard was mailed to Pennsylvania, the Roaring Twenties prosperity had helped many residents buy automobiles, mostly like the Ford Model-T seen in front of the depot. The roads in and out of Malvern were still rough and unpaved, thus passenger trains were the main means to travel outside Hot Spring County. The Missouri Pacific had built the new depot in 1918; it still stands, serving Amtrak passengers, and is on the National Register of Historic Places.

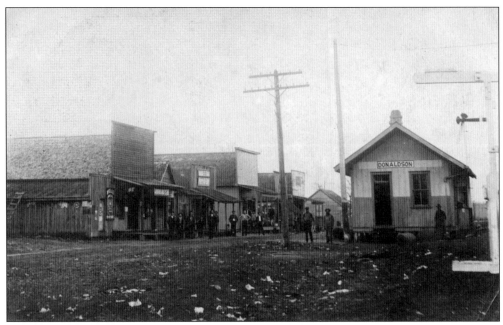

Passengers departing Arkansas to the southwest would have stopped soon at the small town of Donaldson, which sprang up around the rail stop; its small depot is seen to the right. The depot is gone today, but the town of some 300 people remains.

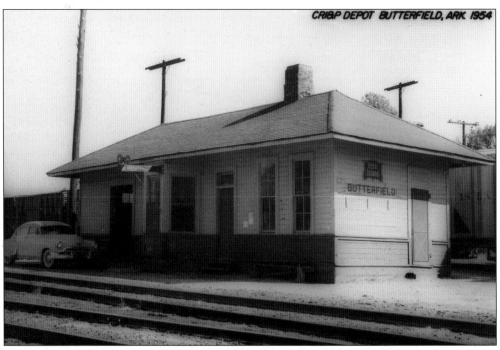

Passengers traveling between Malvern and Hot Springs would have pulled into the depot at Butterfield, served here by the Chicago, Rock Island, and Pacific (CRI&P) Railroad around 1950. Today the depot is gone, as is rail service through the tiny Hot Spring County community.

Two

MAIN STREET MEMORIES

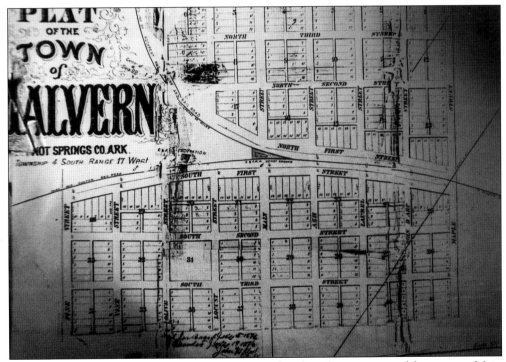

The pattern in most new Arkansas towns saw the railroad mark its station and from it grew Main Street. Malvern was one example, born on the new rails in 1873. Main Street is seen on the plat of the city, running from south to north in the center of the plat above, meeting the depot in the middle. (Courtesy HSC Historical Society.)

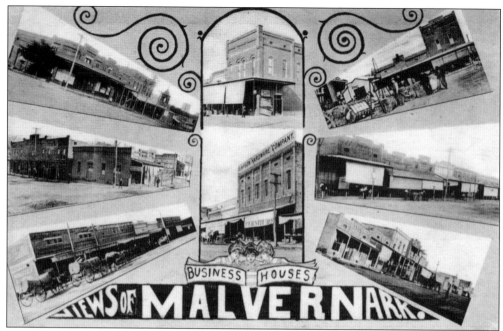

By 1900, the original wooden-frame business district, largely destroyed by an 1896 fire, would see a wide Main Street lined with handsome buildings of brick and stone. The sampling on this community pride postcard included most of Main Street's retailers.

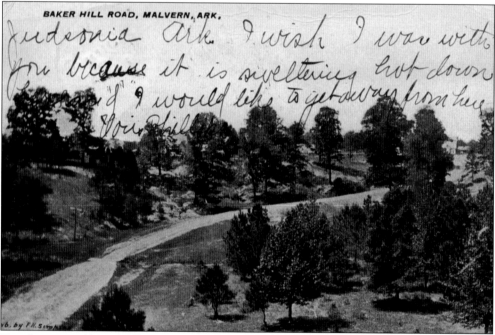

Travelers approaching Malvern in 1909 from the north would have ridden their horse or wagon down Baker Hill, seen here, crossing the railroad tracks and up another hill onto the town's dirt Main Street. The postcard message, sent to Washington state, suggested Lois was not happy in Arkansas: "It is sweltering hot down here, I would like to get away from here."

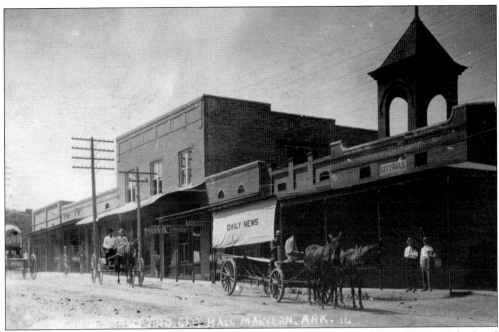

The writer of the card around 1905 sent a view of the wagons passing the city hall and the local newspaper, for which he might have worked. His message read, "I have a couple of expenses about to come to over $100. I am feeling OK, but all I need is printer's ink." The city hall building is long gone.

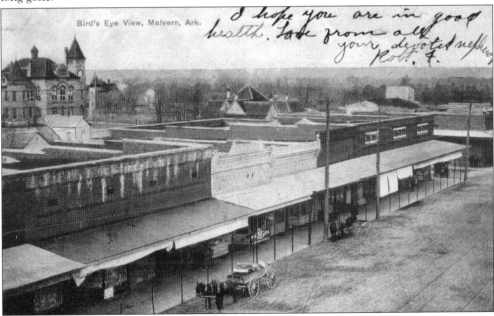

The photographer looked west over Main Street toward the Hot Spring County Courthouse in the distance. Young Robert F. had penned news to his aunt in Virginia in 1908, "I am writing you first about my appointment to the U.S. Naval Academy at Annapolis. I shall be examined in June." Though the courthouse was replaced in the 1930s, most of the Main Street buildings seen here still stand.

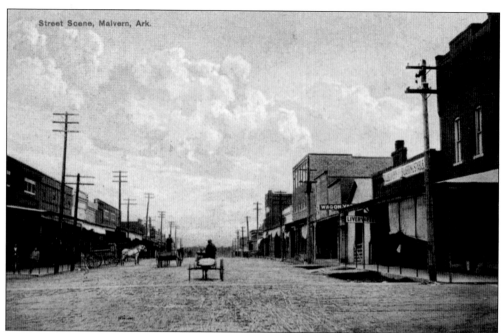

By 1910, Malvern's Main Street was still dirt but wide enough to accommodate wagons loading and unloading for merchants who served the business district. One of these was John Linvall's livery, seen to the right, which operated a feed store in the front and a wagon yard in the back of the business.

By 1915, a symbol of the coming demise of the Linvall's Livery Stable was parked in front of the business, which is seen above in the 300 block of Main Street a few years earlier. (Courtesy HSC Historical Society.)

Linvall's Livery Stable might have gotten some competition for services from Harry Comer, who operated a blacksmith shop across the train tracks north of Main Street at the foot of Baker Hill. Comer, seen here around 1915, posed in the midst of shoeing a horse, who perhaps was putting his best face forward for the camera. (Courtesy HSC Historical Society.)

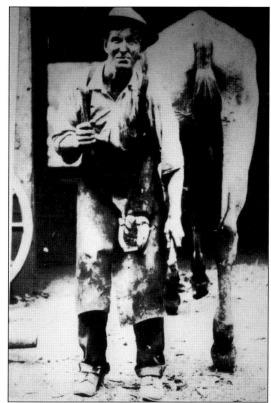

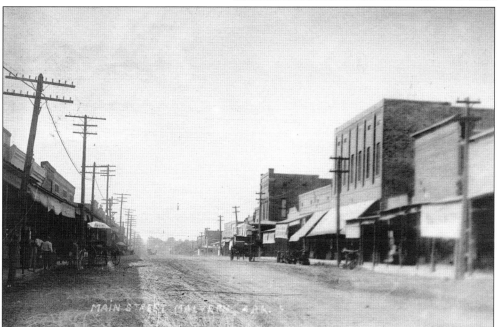

"Here at last, nice town. Malvern, Ark is my address don't forget. I think I will like the country." The new arrival had penciled the message to a lady in Iowa around 1915. The buggy to the left had an umbrella installed to shelter likely a lady from the hot Arkansas sun.

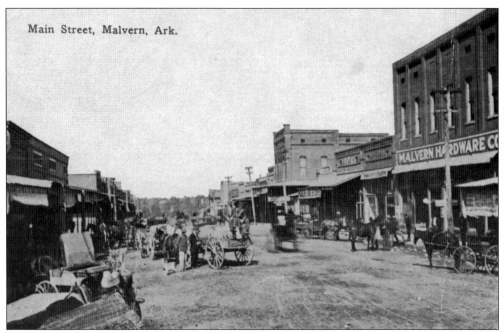

Main Street, Malvern, Ark.

A newly arrived visitor to Malvern in 1913 sent his impressions to Wisconsin. "Friend Charles, you ought to be with us in the sunny south. Your surely would appreciate your trip. Have a nice colored gal in sight. Drop a card, Otto." Perhaps Otto visited the Malvern Hardware Company store on the right, an institution that served the city for decades.

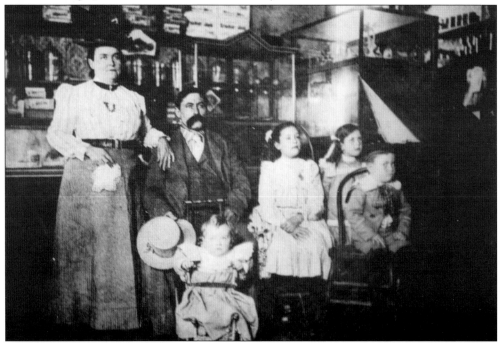

Shoppers with a sweet tooth might have visited the Main Street City Bakery operated by Fred Nuesch and his wife, Josephine. The Nuesches posed here with their four children in 1901. (Courtesy HSC Historical Society.)

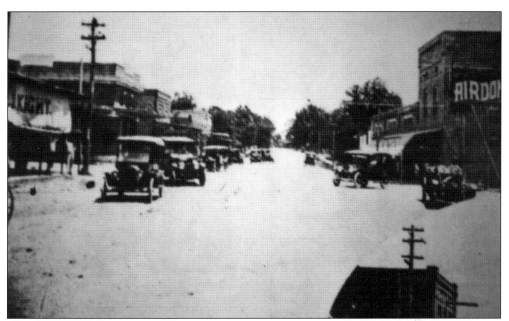

Around 1910, Henry McDonald, president of the First National Bank, constructed an open-air theatre on the corner of West Page and Main Streets. It was enclosed by a high board fence; moviegoers sat on wooden benches. McDonald named his theatre the Air Dome. Note the sign on the right in this *c.* 1915 image. A piano player provided vital emotional cues for viewers of the silent movies. The concession stand sold popcorn, peanuts, candy, ice cream, and chewing gum—all for 5¢. Each package of gum included a coupon that could be redeemed by the Wm. Wrigley Jr. Company. When concessionaire Johnny Wharton sold a pack of gum, he would ask the buyer for the coupon. All of the furniture in his home was obtained with the coupons.

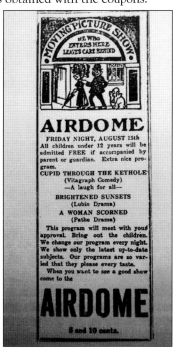

"He who enters here leaves care behind," proclaimed this advertisement for the Air Dome, which ran in the August 14, 1913, issue of the *Malvern Meteor* newspaper. The theatre was showing a triple feature, a comedy and two dramas. Tickets cost 8¢ and 10¢ each. Children under 12 were admitted free if accompanied by a parent or guardian. If it rained during a show, all ticket money was refunded.

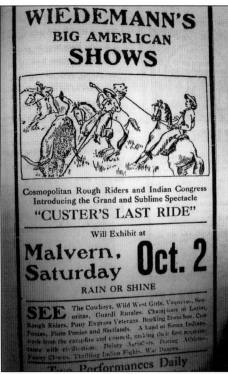

WIEDEMANN'S
BIG AMERICAN
SHOWS

Cosmopolitan Rough Riders and Indian Congress
Introducing the Grand and Sublime Spectacle
"CUSTER'S LAST RIDE"

Will Exhibit at

Malvern, Oct. 2
Saturday

RAIN OR SHINE

SEE The Cowboys, Wild West Girls, Vaqueros, Sen-
oritas, Guardi Rurales, Champions of Lariat,
Rough Riders, Pony Express Veterans, Bucking Bronchos, Cow
Ponies, Pinto Ponies and Shetlands. A band of Sioux Indians,
fresh from the campfire and council, making their first acquaint-
ance with civilization. Dainty Aerialists, Daring Athletes,
Funny Clowns, Thrilling Indian Fights, War Dances.

Two Performances Daily

This advertisement for a "Big American Show" ran in the *Malvern Meteor* newspaper, around 1908. In that bygone era, summer always brought medicine shows peddling "miracle cures" for everything from corns to cancer. The Fourth of July was celebrated with a community picnic, patriotic speeches, games, and fireworks. Throughout the year, Chautauqua lectures featured well-known speakers, teachers, musicians, entertainers, and preachers who often played to a packed house.

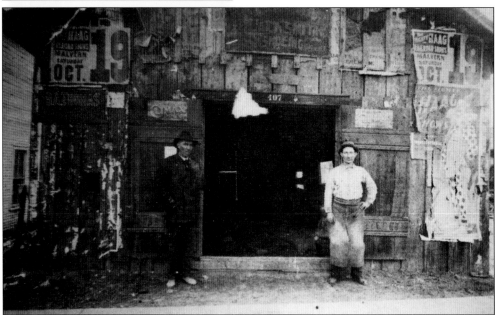

A favorite means of advertising traveling shows like "Custer's Last Ride," as well as those like the circus, was to paste up posters of coming attractions, such as the one on this livery stable near the depot for "Mighty Haag's Railroad Show." The creation of Ernest Haag, the circus was on the road for 43 years, moving from wagons to trains in 1909. Barnum and Bailey referred to Haag as "the Barnum of the Sticks." Haag promised "clean family entertainment" and "no dancing girls." (Courtesy HSC Historical Society.)

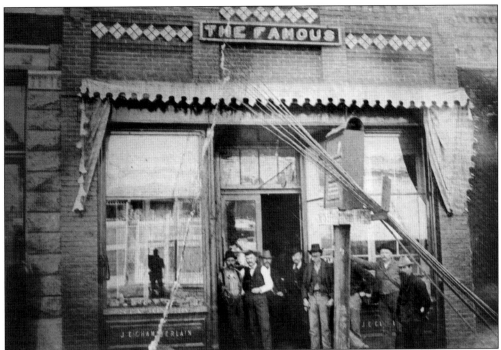

J. E. Chamberlain operated his store on the small town of Malvern's Main Street, but perhaps he thought big naming it "The Famous" store, selling a variety of merchandise. Chamberlain is the second from the left in the vest, white shirt, and tie. To his right are Col. N. P. Richmond, Dr. J. A. Watson, Billie Garrett, and Jim Wheat. Below is one of Chamberlain's *c.* 1915 newspaper advertisements, in which he pleaded excess inventory that was causing him to "forget about the price," especially it seemed on 300 pairs of shoes. (Above, courtesy HSC Historical Society.)

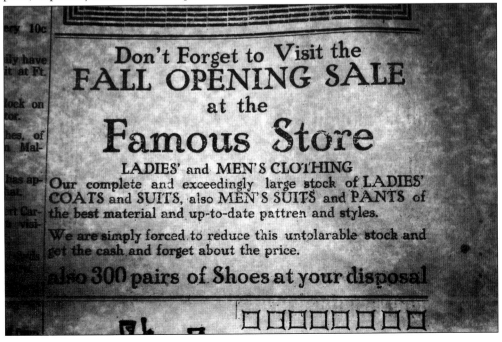

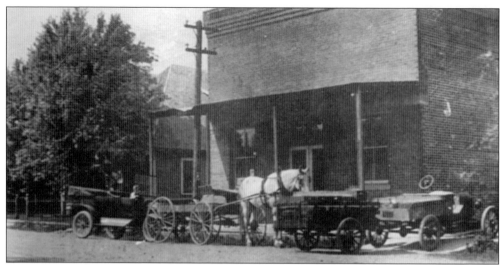

Clem Bottling Works was opened in March 1907 by Dock Clem and his father, J. M. Clem. In May 1914, this plant was opened on South Main Street; the building still stands. Note the horse-drawn delivery wagon and the company's first delivery truck. The leading soft drinks marketed and distributed by the company were Clem's Cola, "r-pep," orange, strawberry, and root beer. Other flavors bottled were cream soda, peach, lemon lime, fruit punch, "pep-up," rock and rye, and chocolate.

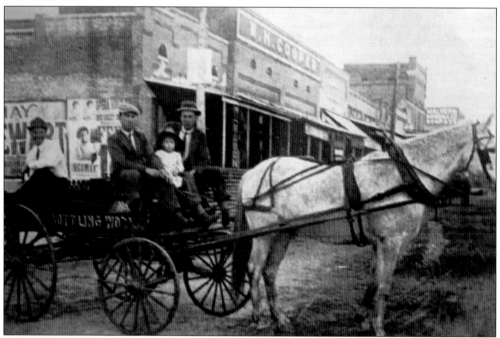

Dock Clem is seated on the back of a delivery wagon in this 1911 photograph. The white horse named Dan pulled the wagon for so many years that he would stop and start at the correct place of his own accord. When Doc Clem died in May 1942, his son Harold took over leadership of the family business. For years, groups, especially schoolchildren, toured the bottling plant. There were always cold drinks for everyone. Clem Bottling Works closed its doors in 1972, after 65 years of continuous operation.

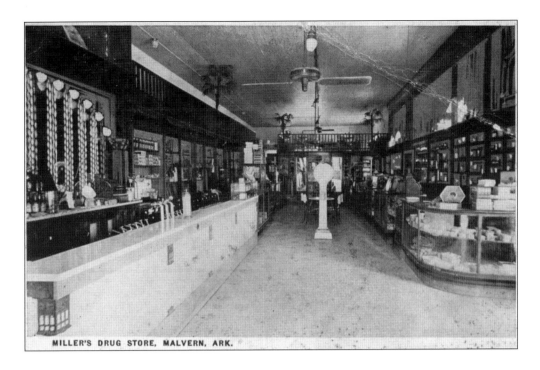

MILLER'S DRUG STORE, MALVERN, ARK.

Founded by Lee Miller in 1890, Miller's Drug Store is Malvern's oldest pharmacy. It moved to its present 231 South Main Street location in the 1920s. Note the ceiling fan, the marble-topped soda fountain on the left, the cigar display case on the right, and the scale at the far end of the aisle in this *c.* 1925 image. Today Miller's Drug Store is owned and operated by fifth-generation Dixon Miller, a great, great grandson of its founder. (Photograph by Ray Hanley.)

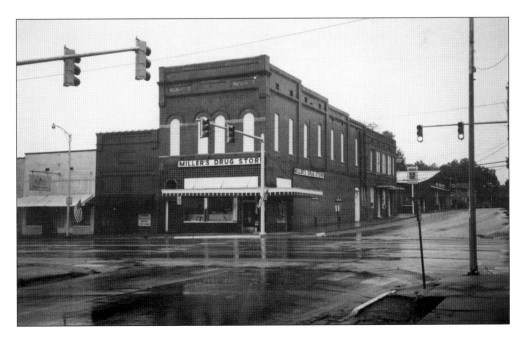

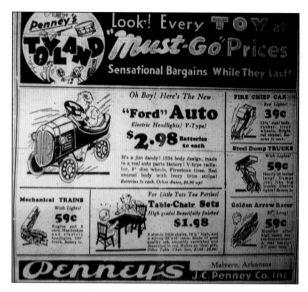

During the Depression era, for the Christmas season of 1934, Main Street icon J. C. Penny advertised its toys in the local paper, including "The New Ford Auto" with "electric headlights" for $2.98, proclaiming it a "Jim dandy." In the same ad were children's letters to Santa. "I am a little girl past three years old and I want you to bring me a tub and wash board." Young Bobby Twitty wrote, "I want a big wagon, so I can haul mother's wood. Also a cowboy's suit." Eight-year-old Helen Verser closed her letter with, "Remember all my little school mates and orphan children."

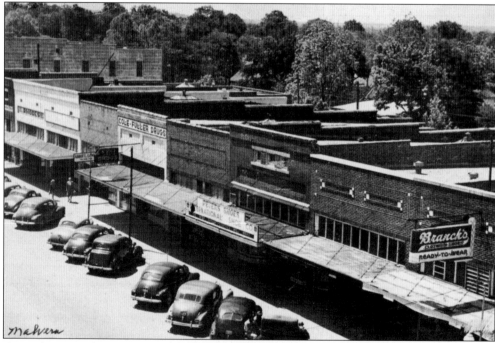

Around 1940, a photographer stood atop a building on the east side of Main Street and pointed his lens to the southwest. He captured the Keith Hotel on the far left, the Cole-Fuller Drug Store, and Branch's Ready to Wear clothing store. In the photograph, the outlet for the International Shoe Company in the center of the block is also discernible. At the time, years before most of the industry moved overseas, the shoe manufacturer had a large factory located in north Malvern.

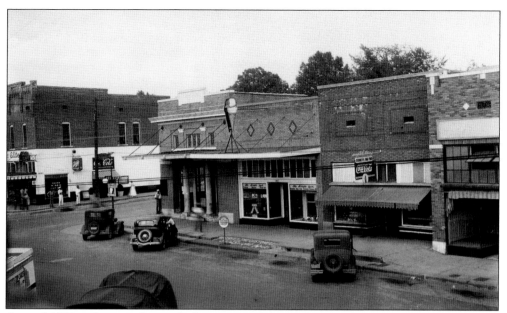

Around 1935, a photographer took this picture of the eastern side of Main Street, capturing an image of the Bright Spot Café between the parked cars and the Elite Café on the far left corner. Hanging from the wall of the Elite Café is a Schlitz Beer sign. Malvern would be voted "dry" after World War II and remains so today. It is illegal to sell alcohol in Hot Spring County.

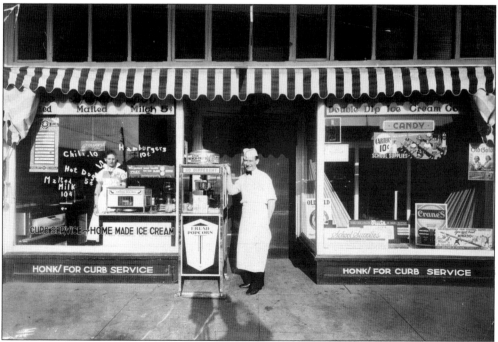

The Bright Spot Café was in business by the 1930s and during World War II was especially popular, with a dance floor on the second level of the business. The popcorn machine stood in the front entrance, enticing strolling shoppers. The menu prices are noted in the windows. The business was gone by the 1950s.

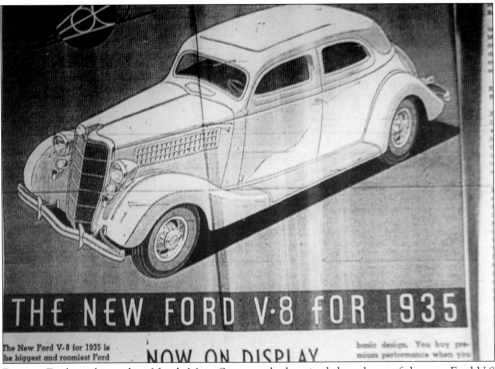

Ramsey Ford was located on North Main Street and advertised the release of the new Ford V-8 for 1935. The car came in 12 different models, ranging in price from a Coupe at $495, a deluxe roadster with rumble seat for $550, up to the touring sedan for $695. With the Great Depression still on, few residents could afford a new car.

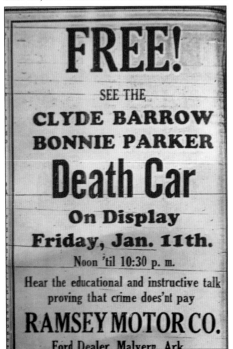

To generate floor traffic in the showroom in 1934, Ramsey Ford turned to a subject of public fascination, Bonnie and Clyde. The outlaw couple, who had killed a number of policemen among others, had finally paid the price for their crimes when a hail of 167 bullets riddled the car they were driving in rural north Louisiana. Ramsey had arranged to have the "death car" of the outlaws on display a few months later at his dealership.

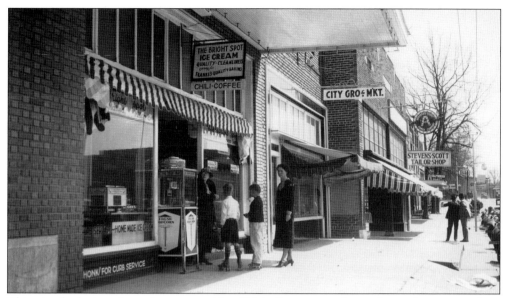

This view looked south on the eastern side of Main Street, past the mother and two young boys eyeing the Bright Spot Café's popcorn machine. Next door was the City Grocery in an era before the supermarket, and farther down Stevens-Scott Tailor Shop is seen.

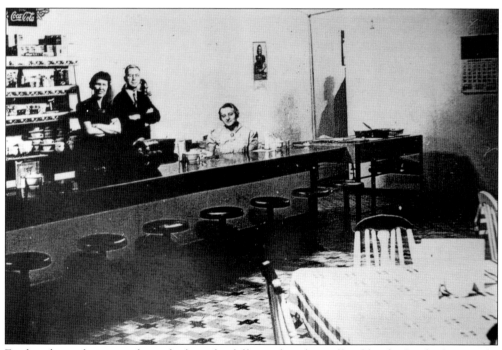

Farther down the street, diners looking for different fare than offered by the Bright Spot might have wandered into the Means Café, with a choice of table or bar stool seating. Mrs. Means, the proprietor, is seated behind the counter. (Courtesy HSC Historical Society.)

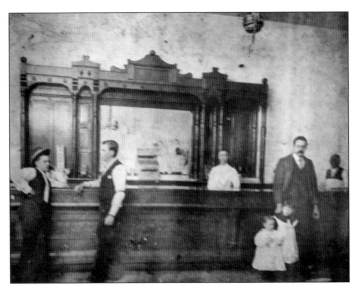

The interior of Malvern's White Elephant Saloon is seen at left in the late 1890s. The man at the end of the bar is identified as Mr. McWhorter. The heavyset man with two children is W. D. "Big Will" Alexander, proprietor of the barroom. The children are his daughter Annie Gray and his son Joseph. There is a sign on the wall for Battle Ax Chewing Tobacco, an ornate mirror, and brass cuspidors at the end of the bar.

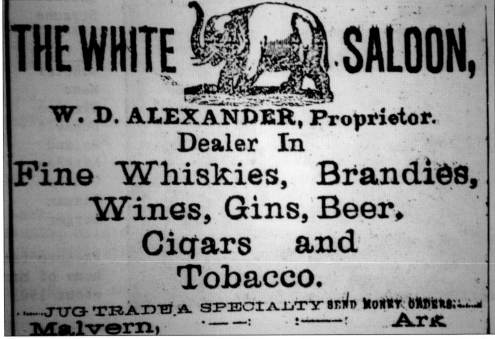

This advertisement for the White Elephant Saloon ran in the *Malvern Meteor* around 1908. The town's bars did a brisk business until 1902, when most of them became victims to the so-called "3-mile law." This law mandated the closure of saloons operating within a 3-mile radius of a public school. In 1915, five years before passage of national prohibition, the Arkansas General Assembly passed the Newberry Act, banning the manufacture and sale of alcohol within the state. With the repeal of national prohibition in 1933, Malvern once again became "wet." In 1943, the Ministerial Alliance successfully petitioned for an election, and Malvern and Hot Spring County were voted dry and remain so today.

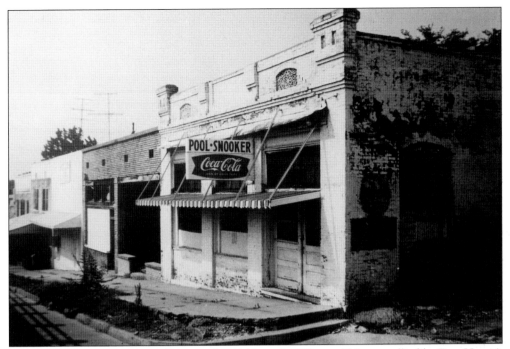

Young boys growing up in Malvern in the 1940s and 1950s would have walked by Pete Harris's Pool and Snooker parlor with a glance through the door. Actually entering the establishment would have drawn the wrath of their mothers upon arrival home. The business was located at the end of the Main Street business district on a slope that dropped down to the train depot and the budget Barlow Hotel. (Courtesy HSC Historical Society.)

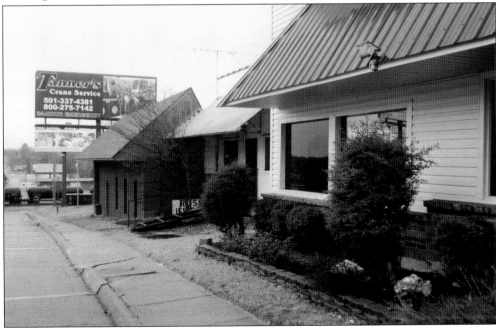

The Pool and Snooker bar, along with most of the block, was razed years ago and is now home to a florist on the right and the Ross Jewelry business farther down. (Photograph by Ray Hanley.)

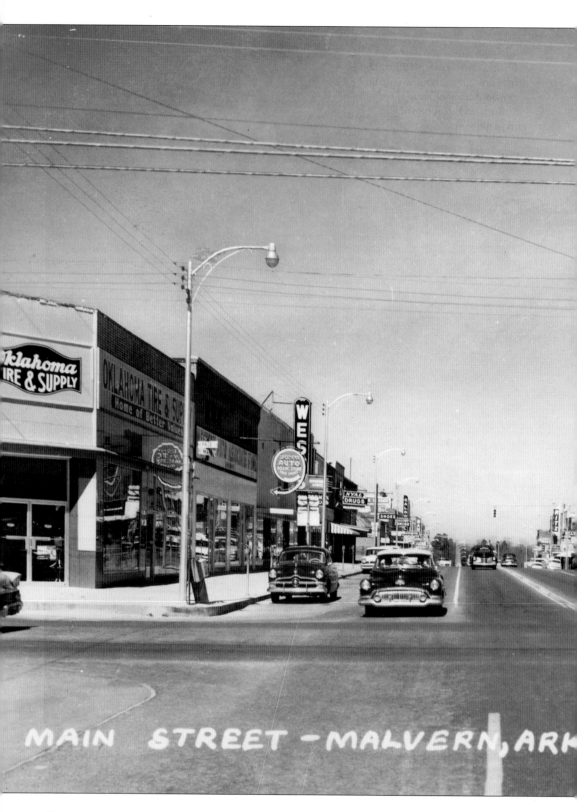

MAIN STREET – MALVERN, ARK

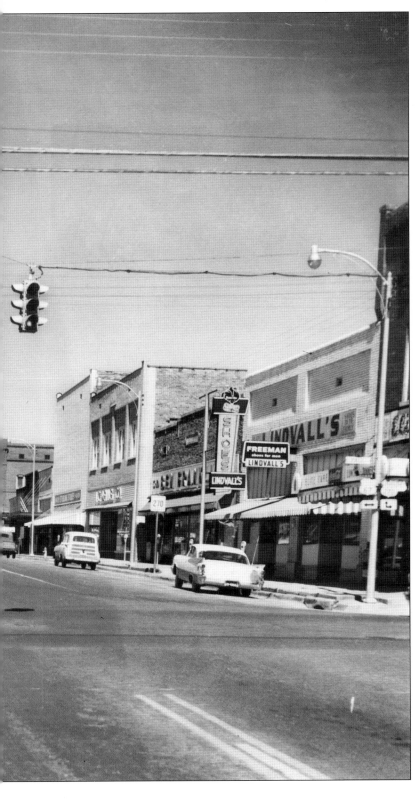

By 1958, Malvern's Main Street was lined with stores common to the small towns of the South, like Ben Franklin's and Sterlings Five and Dime on the right and Oklahoma Tire and Supply, Western Auto, and West Brothers Department Store on the left. Homegrown family businesses like Linvall's and the Elite Café anchored the rest of the block's corner on the right. Barely discernible in the distant right is the sign above the marquee for the Ritz Theater. The photographer stood in the center of the street pointing the lens north across the intersection of Main Street and Page Avenue, which was also the route of U.S. Highway 67. Prior to the coming of U.S. Interstate 30 in the 1960s, some 5 miles outside of town, U.S. Highway 67 brought thousands of motorists each week through the heart of downtown Malvern. For a look at the same view today, see page 46.

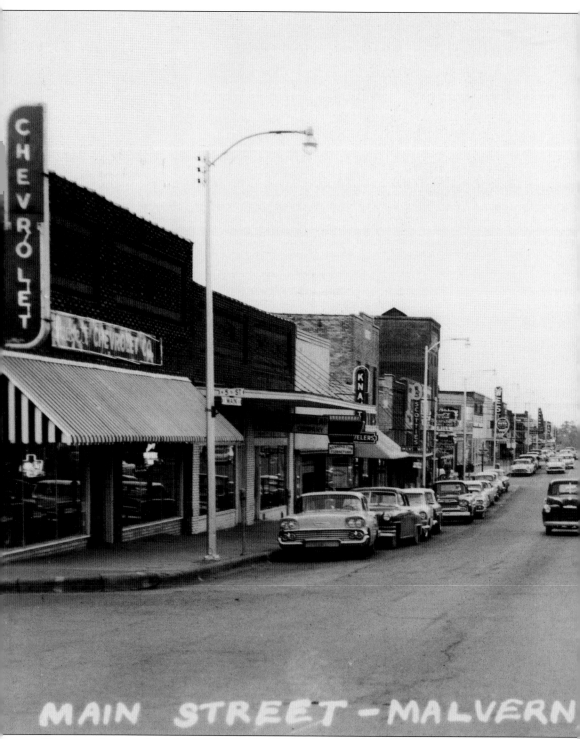

MAIN STREET - MALVERN

The same photographer who, in 1958, took the photograph on the previous page, moved a block farther south on Main Street, looking again north with his camera. The view captured the Chevrolet dealership on the left. To the right, the photograph revealed a block of family-owned

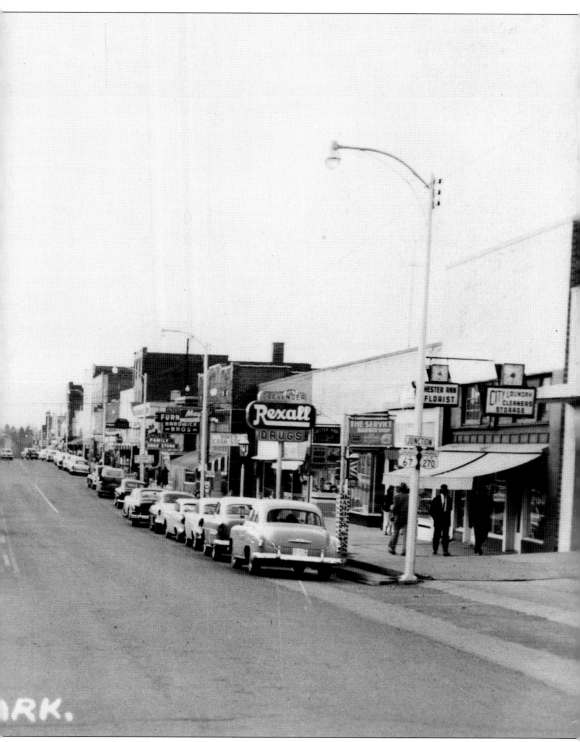

RK.

enterprises such as Hardwick Brothers Furniture, the City Laundry, and the Rexall drugstore. Turn to page 46 for a look at the same view today.

Turn to page 46 for a look at the same view today.

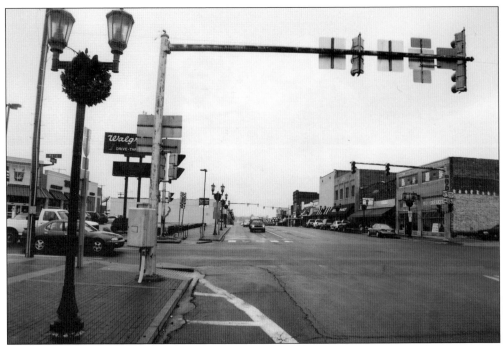

The vantage point seen on pages 42–43 is seen here in 2010, and the contrast is a sharp reflection of what has happened to Main Streets across the nation. Half the block that housed Oklahoma Tire and Supply and Western Auto was razed a few years ago, replaced now by a Walgreens, built in the same style as thousands of other stores in the massive chain. Across the street, the corner where the Elite Café stood in 1958 is a vacant slab. Retailers from 1958 like Ben Franklin's and Sterlings have faded into history in the age of Walmart. (Photograph by Ray Hanley.)

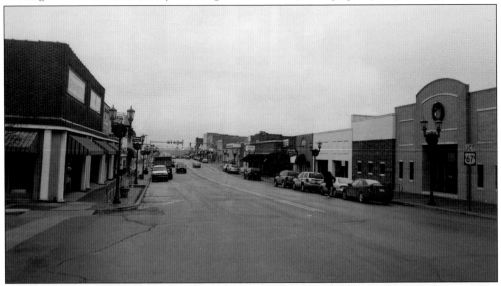

The view on pages 44–45 looked north down Main Street in 1958 just as this view does in 2010, showing an altered, though largely intact, architectural landscape. The Chevrolet dealership moved to the outskirts of town many years ago. The block on the right has seen the 1958 storefronts considerably remodeled and now housing different businesses. (Photograph by Ray Hanley.)

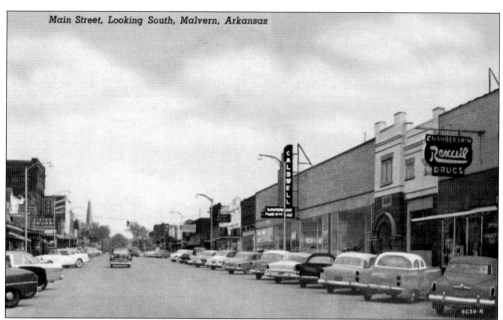

Main Street, Looking South, Malvern, Arkansas

Postcards like this one of Malvern in 1956 were manufactured by the Curteich Company of Chicago, which turned out images like these nationwide for many years, leaving a rich legacy of historical images. The view above looked south on Main Street from the northern end of the retail district. The steeple of First Baptist Church is seen in the far left distance. The postcard, actually published for Chamberlain's drugstore seen to the right, captured at least three drugstores in the era before the rise of chain pharmacies.

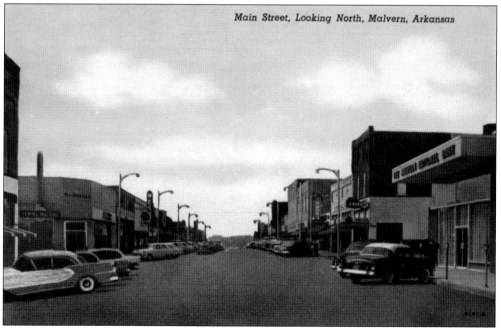

Main Street, Looking North, Malvern, Arkansas

Chamberlain's Rexall Drugs also had this postcard published and sold in a rack in the store in the mid-1950s. It looked north down Main Street across the intersection of Page Avenue (also U.S. Highway 67) with Malvern National Bank on the right and just beyond it, the Elite Café.

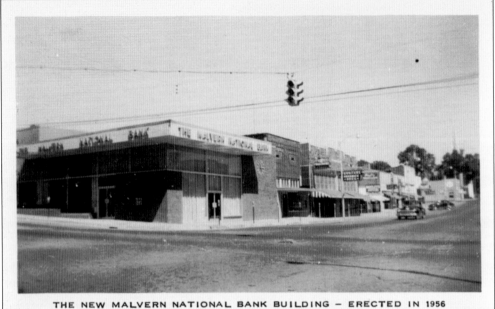

THE NEW MALVERN NATIONAL BANK BUILDING — ERECTED IN 1956

Malvern National Bank opened for business in 1934 at the height of the Great Depression. During its 76-year history, only six individuals have served as its president. Today the thriving financial institution has locations in Hot Spring, Garland, Grant, and Saline Counties. It retains a major center, on the corner of Page Avenue and Main Street, seen here in the mid-1950s.

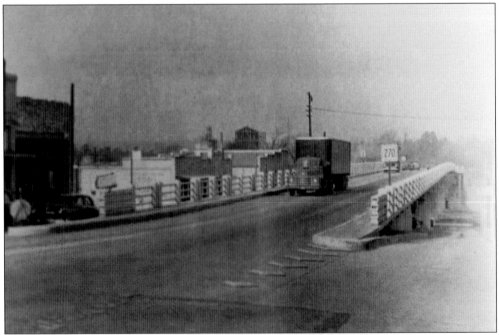

The mid-1950s also saw a long-worked-for goal achieved, the funding and construction of a viaduct that would carry traffic over the shared route of U.S. Highway 270 and North Main Street into downtown Malvern. The railroad tracks that the bridge spanned carried a history of tragedy that helped propel the state to have the overpass built.

For some 50 years, traffic traveling the north end of Main Street had to drive over several sets of railroad tracks, a shared intersection of rail and automobiles that sometimes had tragic consequences. The 1955 Malvern High School yearbook was dedicated to John Ronald Hardwick. The only child of a prominent furniture merchant was killed at the age of 17, when the automobile he was riding in was struck by an oncoming train at the crossing.

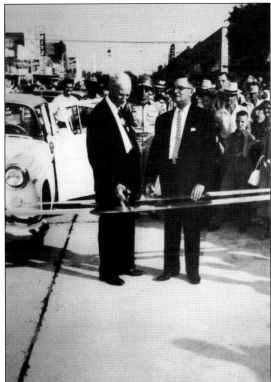

The death of young Hardwick, as well as other deaths and injuries over the years, helped win the state funding to erect a viaduct over the expanse of train tracks that had given Malvern birth in the 1870s. County judge E. A. Wallace (left) and Malvern mayor Lester Pate are shown cutting the ribbon opening the bridge in 1957.

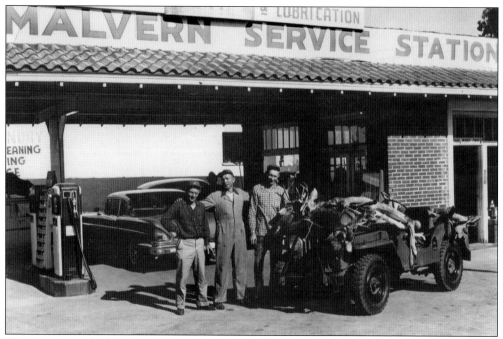

Service stations had cropped up on Main Street's south and north sides by the 1940s. The one seen here was operated by Orval Murry (center), posing at his business located at Main and Pine Bluff Streets around 1958. Deer hunters, Crit Stuart (left) and Cotton Smith, had stopped by to show off their kills, laid atop a still-shiny World War II surplus military jeep. (Courtesy Shirley Murry Henry.)

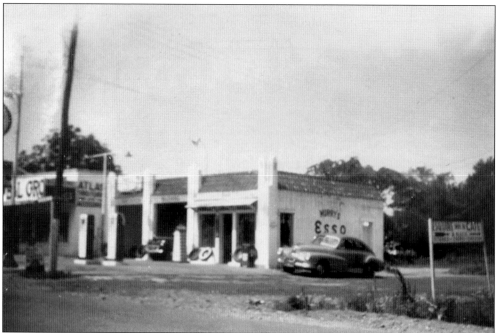

Orval Murry would also operate an Esso station on North Main Street, seen above. Murry raised his family on Baker Street, only a few blocks from his business. (Courtesy Shirley Murry Henry.)

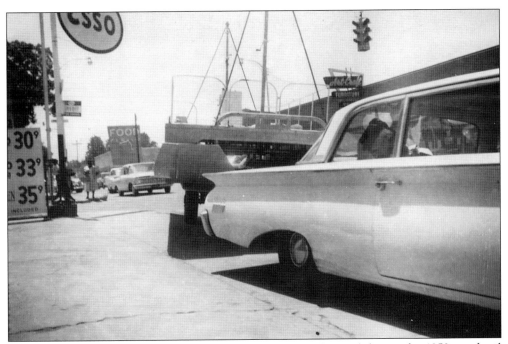

By 1960, Main Street was crowded with the big cars manufactured during the 1950s, and tail fins were much in evidence. Gasoline was getting expensive for some though, above 30¢ a gallon at the Esso on South Main Street. Up the street is the sign for the Food Center, Malvern's first supermarket-style grocery, and it remains a retail anchor today at the same location. The Artcraft Furniture store, its sign seen below the traffic light, closed a number of years ago.

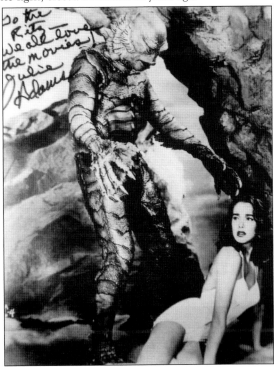

Born in Waterloo, Iowa, actress Julie Adams was raised in Malvern, and she left her own impression in a Main Street theater. She is best remembered for costarring with actor Richard Carlson in the classic 1954 science-fiction flick *The Creature From the Black Lagoon*. This photograph from the movie, autographed by Julie Adams, hangs in the lobby of the Ritz Theatre. She also costarred in many Westerns, among them, *Bend in the River* with Jimmy Stewart and *Man From the Alamo* with Glenn Ford. (Courtesy of Ritz Theater.)

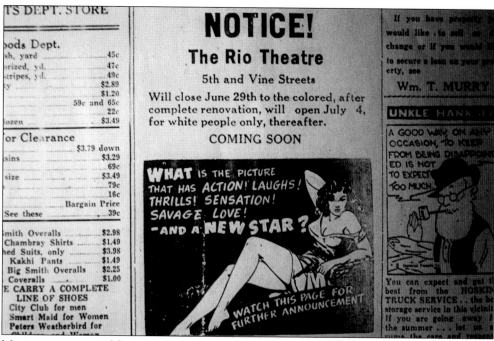

'S DEPT. STORE

ods Dept.
sh, yard 45c
rized, yd. 47c
tripes, yd. 49c
ty $2.89
............................... $1.20
59c and 65c
............................... 22c
ozen $3.49

or Clearance
............... $3.79 down
sins $3.29
............................... 69c
size $3.49
............................... 79c
............................... 16c
Bargain Price
See these 39c

mith Overalls $2.98
Chambray Shirts $1.49
hed Suits, only $3.98
Kakhi Pants $1.49
Big Smith Overalls $2.25
Coveralls $1.00
E CARRY A COMPLETE
LINE OF SHOES
City Club for men
Smart Maid for Women
Peters Weatherbird for

NOTICE!

The Rio Theatre

5th and Vine Streets

Will close June 29th to the colored, after complete renovation, will open July 4, for white people only, thereafter.

COMING SOON

WHAT IS THE PICTURE THAT HAS ACTION! LAUGHS! THRILLS! SENSATION! SAVAGE LOVE! — AND A **NEW STAR?**

WATCH THIS PAGE FOR FURTHER ANNOUNCEMENT

If you have property would like to sell or change or if you would to secure a loan on your erty, see

Wm. T. MURRY

UNKLE HANK

A GOOD WAY ON ANY OCCASION, TO KEEP FROM BEING DISAPPOINTED IS NOT TO EXPECT TOO MUCH.

You can expect and get the best from the HOSKIN TRUCK SERVICE , the be storage service in this vicinit If you are going away f the summer . . . let us

Movies were a part of downtown Malvern from the days of the silent films onward. In 1934, the Rio Theater, exclusively for African American patrons, was located at Fifth and Vine Streets, a short distance off Main Street. In running a racy advertisement teasing the audience about an upcoming film, the Rio also announced it was preparing to close for renovation. Upon reopening, it no longer catered to African American patrons but sat only white people.

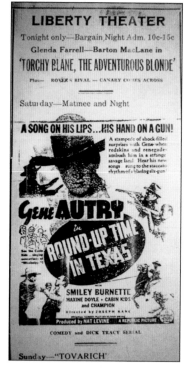

LIBERTY THEATER

Tonight only—Bargain Night Adm. 10c-15c

Glenda Farrell—Barton MacLane in

'TORCHY BLANE, THE ADVENTUROUS BLONDE'

Plus— ROGER'S RIVAL — CANARY COMES ACROSS

Saturday—Matinee and Night

A SONG ON HIS LIPS...HIS HAND ON A GUN!

A stampede of shock-filled surprises with Gene when redskins and renegades ambush him in a strange savage land! Hear his new songs sung to the staccato rhythm of a blazing six-gun!

GENE AUTRY in ROUND-UP TIME IN TEXAS

SMILEY BURNETTE
MAXINE DOYLE - CABIN KIDS
and CHAMPION
Directed by JOSEPH KANE A REPUBLIC PICTURE

COMEDY and DICK TRACY SERIAL

Sunday—"TOVARICH"

By early 1938, the Rio Theater was apparently gone, and Malvern's movie audiences found their entertainment at the Liberty Theater located in the 400 block of Main Street. On bargain night, for as little as 10¢ admission, one could have seen *Torchy Blane, the Adventurous Blonde*. Also playing was an "oater" Western starring Gene Autry, along with a Dick Tracy serial.

The Liberty Theater would be outclassed with the opening of the Ritz in December 1938. Located at 213 South Main Street, the Ritz Theatre was designed by the Little Rock architectural firm of Brueggeman, Swaim, and Allen. When it opened, it was reportedly the first theatre in the South to have air conditioning. The premiere attraction was *The Mad Miss Manton*, a murder mystery starring Barbara Stanwyck and Henry Fonda. Local actress Catherine O'Quinn had a supporting role in the movie. Per the advertisement, admission on opening night was 10¢, 30¢, and the balcony was reserved for African Americans, as was common across the South at the time. The main auditorium at the Ritz would be integrated after 1960.

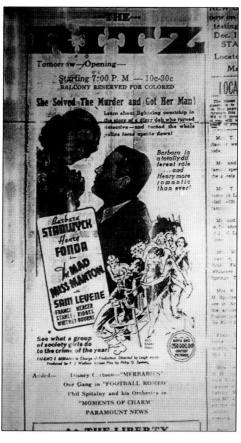

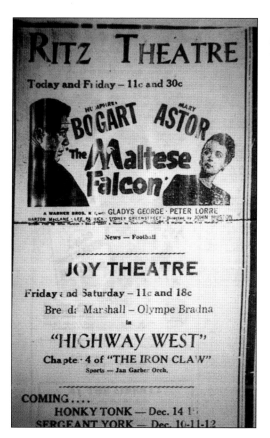

In the decades to come, the Ritz was the Malvern showcase for the biggest films of Hollywood, including 1941's *Maltese Falcon* starring Humphrey Bogart. A few blocks away, the Joy Theater could only offer up *Highway West* and chapter four of *The Iron Claw*, with coming attractions of *Honky Tonk* and what would be an Academy Award–winning *Sergeant York*.

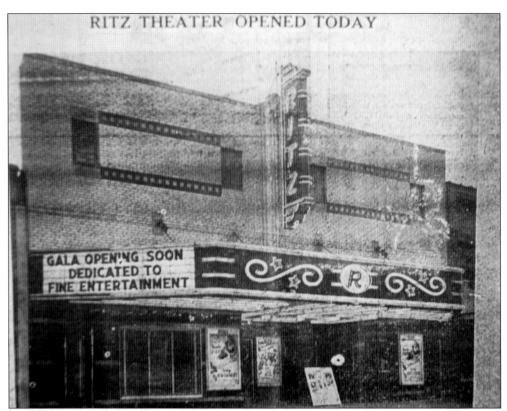

RITZ THEATER OPENED TODAY

GALA OPENING SOON
DEDICATED TO
FINE ENTERTAINMENT

In February 1948, the Ritz was destroyed by fire. The fire chief was away with the town's only fire truck, fishing on the river. By the time a fire truck arrived from Hot Springs, it was too late to save the theater. The city would fire its chief and replace him with Odus Allbritton, who went on to build an outstanding department. The Ritz reopened eight months later (above) with more neon lighting, a larger marquee, tile restrooms, and a cry room. Remodeled in 1982 and again in 2004, the landmark closed in August 2008 but was reopened (below) in early 2009 through the efforts of Marty and Marla Nix. Malvern is one of a handful of small Arkansas towns to still offer its residents a Main Street movie experience.

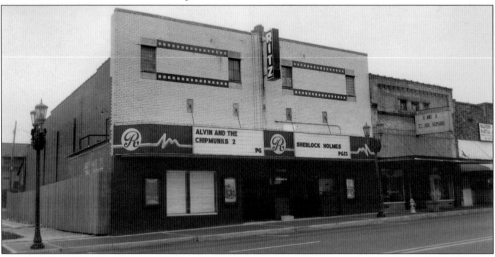

Three

THE NATION'S PATH THROUGH HOT SPRING COUNTY, U.S. HIGHWAY 67

Malvern was born with the coming of the railroad, but it would be the coming of U.S. Highway 67 that would bring the hundreds of thousands of motorists through the town beginning in the 1920s. In the 1920s, the roads were rough dirt routes of loosely connected roadway entering the state from Missouri and exiting at Texarkana. The photograph above captured an automobile coming into Malvern from the east on the dusty track, passing C. W. Ray's Feed and Groceries. Ray also sold Standard gasoline from the gravity-fed pump on the front porch of his store.

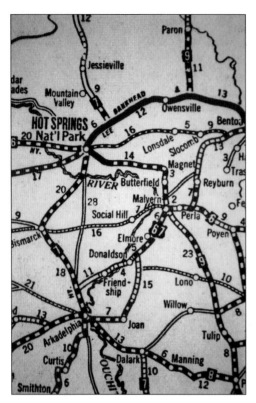

By the early 1930s, as evidenced by the map section to the left, the road had been given the "U.S. Highway 67" label, but the entire link through Hot Spring County was still unpaved from Benton in Saline County into Arkadelphia and the rest of southwest Arkansas. A motorist leaving the pavement at Benton would have come through Reyburn, Perla, Malvern, Elmore, skirted Donaldson, and come, after a dusty ride, into Clark County.

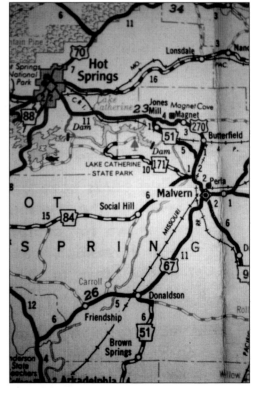

By the 1940s, U.S. Highway 67 had been paved for its entire length through the state, including the Hot Spring County sections. It had rerouted somewhat at Donaldson, striking a bit north and west to pass through Friendship, and entering Caddo Cap in Clark County. On the other hand, U.S. Highway 171 leading to Lake Catherine State Park was still a dirt and gravel road, as was U.S. Highway 84. Since the late 1960s, U.S. Interstate 30 has moved the traffic west of the Ouachita River, forever taking the journeys of many thousands of people off U.S. Highway 67 and out of downtown Malvern.

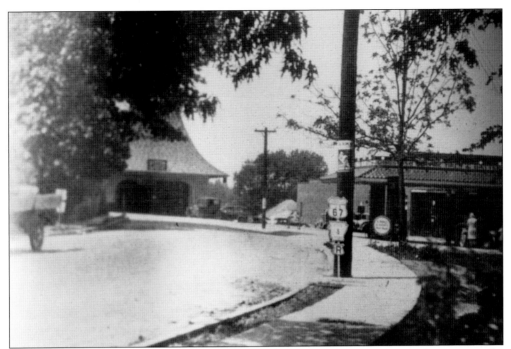

Approaching Malvern's Main Street around 1930, a motorist would have seen the signs on the pole for U.S. Highway 67 and Arkansas State Road 6 (today's U.S. Highway 270). The road was yet to be paved but had gained concrete curbs for the city section. There were two gas stations at the intersection. Gibson's, to the right, had a sign on the curb reading "Ladies and Gent's Restrooms." The building with the high roof is also a gas station, although with undetermined brand.

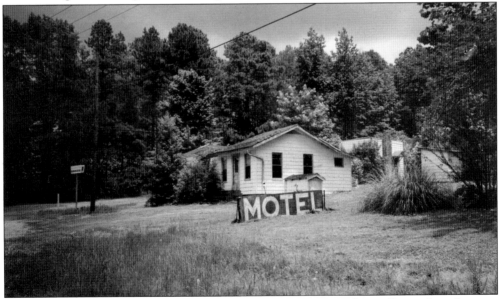

By the late 1930s, with the completion of the paving of U.S. Highway 67, motels and tourist courts began to dot the roadway on the northeastern side of Malvern. Remnants of the lodging of the now-interstate-bypassed highway still can be found, as in this photograph taken some 2 miles east of Malvern in 1999. (Courtesy Ray Hanley.)

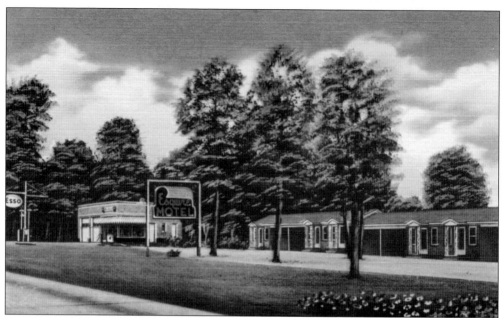

Sitting an advertised 2.5 miles northeast of Malvern on U.S. Highway 67, as seen on this c. 1945 postcard, was the Esquire Motel, a café, and an Esso gas station owned by Mr. and Mrs. W. E. Holley. The motel advertised "Private Tile Baths, Air Conditioning, Panel Ray Heat, and Beautyrest beds." A room for two at the time would have cost $2 to $3 a night.

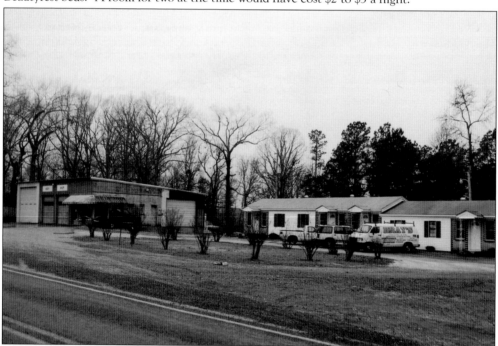

In 2010, a driver on the much less busy U.S. Highway 67 would still pass by what had been the Esquire Motel. Today the former motel rooms have been converted into apartments, and the former gas station and café to the left is now an automobile body shop. The individual garages that once went with each motel room have been filled in to make larger apartments. (Photograph by Ray Hanley.)

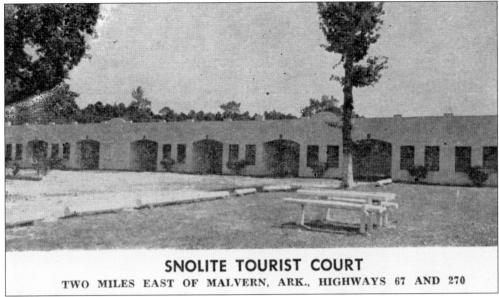

SNOLITE TOURIST COURT
TWO MILES EAST OF MALVERN, ARK., HIGHWAYS 67 AND 270

Nearing the eastern edge of the Malvern city limits, the U.S. Highway 67 motorist soon came to the Snolite Tourist Court, seen here in the 1940s at the junction of U.S. Highway 67 and Arkansas Route 270, the road to Sheridan and Pine Bluff. Each room had an adjoining covered space to park the guest's automobile. The Snolite was razed years ago.

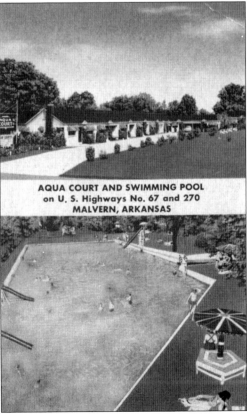

AQUA COURT AND SWIMMING POOL
on U. S. Highways No. 67 and 270
MALVERN, ARKANSAS

Upon entering the eastern city limits of Malvern, the U.S. Highway 67 traveler, perhaps at the urging of children in the backseat of the then un-air-conditioned car, might have pulled in at the Aqua Court. The court's name came from its advertised very large swimming pool, which was fed by a spring. Also advertised was a café and "Play Garden" and Beautyrest mattresses on every bed. The court had been built by Pete Harris, who also owned the billiard hall seen on page 41. The swimming pool is long gone, with the motel rooms converted to apartments.

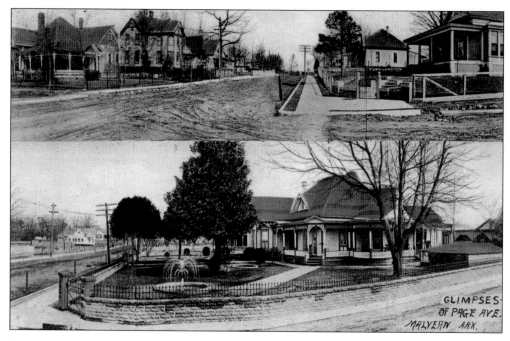

The evolution of the increasingly modern U.S. Highway 67 over the years changed not only the comfort of the motorist but also the view along East Page Avenue, the street sharing the route. Large homes, with often expansive yards, had begun to dot the avenue around 1900. The 1909 postcard above captured a dirt street, bordered by sidewalks passing before the handsome homes of the successful businesspeople of Malvern. Pictured below, the home of W. H. Cooper once stood at the corner of East Page Avenue and Ash Street. The site today is a parking lot for Brookshires grocery store as it, as well as the other homes, is gone but in the history books.

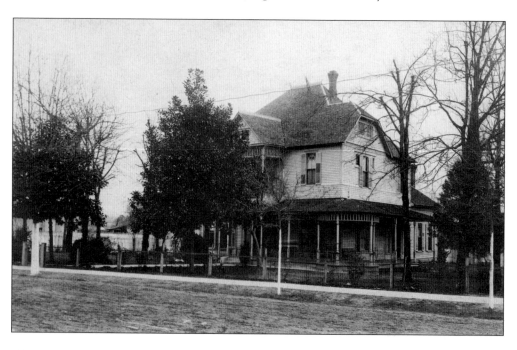

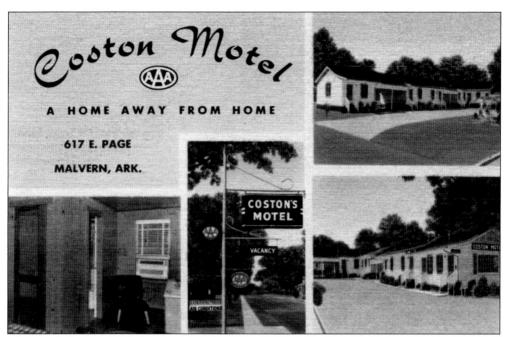

The motels on U.S. Highway 67 closer to downtown Malvern were a bit more compact, with less surrounding gardens and yard. Such was the Coston Motel, "A Home Away From Home," owned at the time of this c. 1945 card by Mr. and Mrs. J. Golden. The business could be reached with a simple three-digit phone number, 635. The motel still operates today but under a different name.

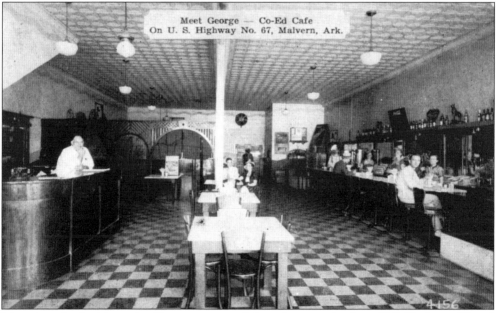

Motorists checked into the Coston or one of the other motels along U.S. Highway 67 and headed out in search of a meal, ending up perhaps at George's Co-Ed Café. In then-wet Hot Spring County, the café sold beer, with bottles on display above the counter on the right on this postcard mailed in 1938.

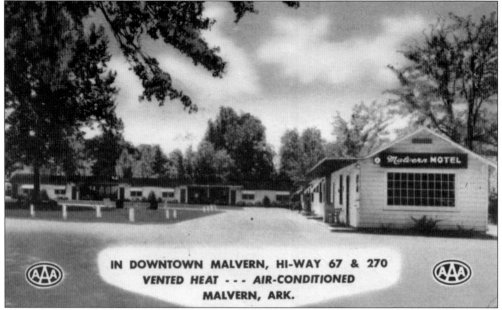

IN DOWNTOWN MALVERN, HI-WAY 67 & 270
VENTED HEAT - - - AIR-CONDITIONED
MALVERN, ARK.

The closest tourist court to downtown Malvern on U.S. Highway 67 for years would be the Malvern Motel. The motel opened in 1948, built by Vance Jernigan and L. M. "Bud" Mange. Among its amenities for 14 rooms, or cabins, were individual garages. Each of the cabins was done in knotty pine paneling with textone ceilings and was equipped with a built-in vanity and chest of drawers. Each cabin was heated with Panelray wall heaters and dressed out with Venetian blinds and draped windows, below which was an air conditioner for each room. The Magnolia Cafeteria, popular with motel guests and city residents alike, shared the grounds of the motel. The postcard above is dated 1953, five years after opening, and the one below, showing substantial remodeling, comes from the early 1970s. Today the motel is gone; the site is occupied by a McDonalds.

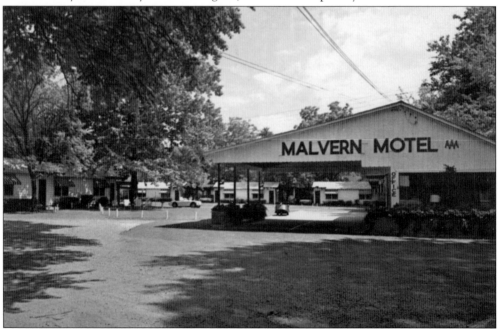

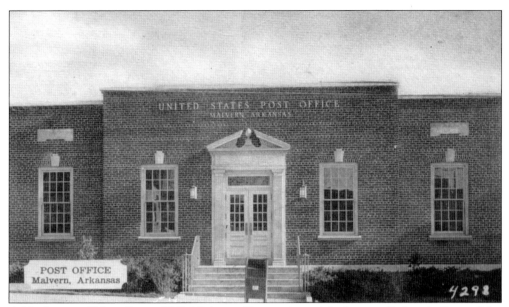

A block east of Main Street, U.S. Highway 67 motorists might have pulled up in front of the Malvern Post Office to drop a postcard in the mailbox out front. Mitchell Thompson, identified as a post office clerk, mailed this card in 1938 to Wisconsin saying, "We are very glad to comply with your request." The Methodist church on the east side of the post office bought it in the 1970s and wrapped a remodeled, expanded church around the building, leaving it unrecognizable. A new post office had opened farther back down East Page Avenue.

Certainly among the postcards dropped in the box at the vintage Malvern Post Office were some like this one printed for local merchants, "The Fish Keep You Busy Here." The postcard would have been among the stock at cafés and other businesses located along U.S. Highway 67.

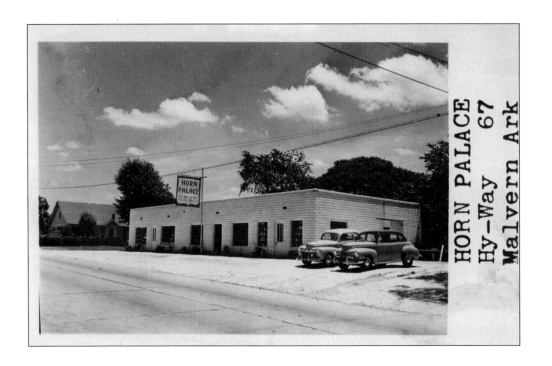

In the late 1940s, Ray Davidson bought the Hy-Way 67 Grill and changed the name to the Horn Palace. Along with burgers, fries, and "blue plate specials," the establishment offered furniture and other novelty items, many made with cow horns and deer antlers. Note the cougar rug on the floor and the animal pelts and Native American head plaques on the wall.

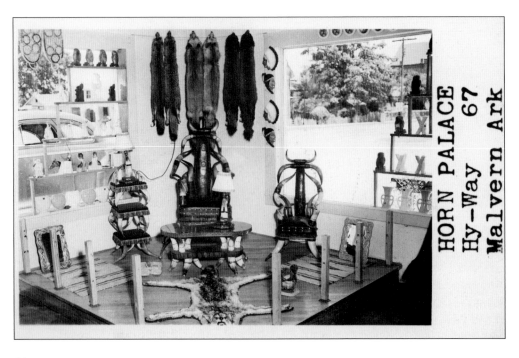

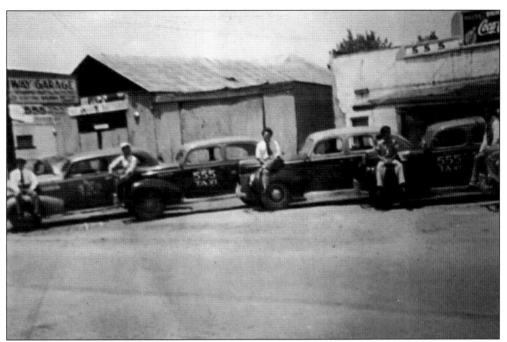

Motorists leaving Malvern on U.S. Highway 67 hoped they would not have to call Earnest Burks 555 Wrecker Service. However, they might have grabbed lunch at his 555 Café or, if in need of transportation while their car was in the garage to the left, they might have availed themselves of Burk's 555 Taxi, several of which are parked in front of the business.

The Horn Palace was not the only tourist trap on the western outskirts of U.S. Highway 67's path out of Malvern. Smith's Outlet Store catered to travelers with a series of postcards, including this one showing a father suffering through rest stops with his family.

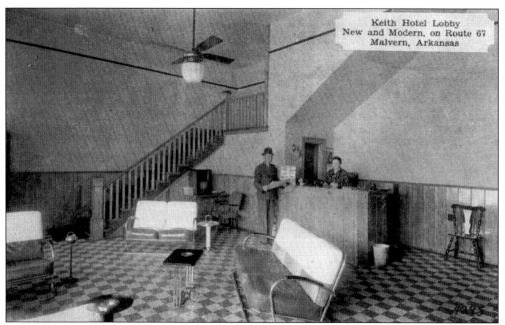

The Keith Hotel, a portion of which is seen above, sat on the southwest corner of Main Street for some 50 years, offering convenient lodging for the traveling businessperson. There are at least four ashtrays visible in the seating area of the hotel lobby. The rise of the motels along Page Avenue later took away much of the hotel business, and the building was razed.

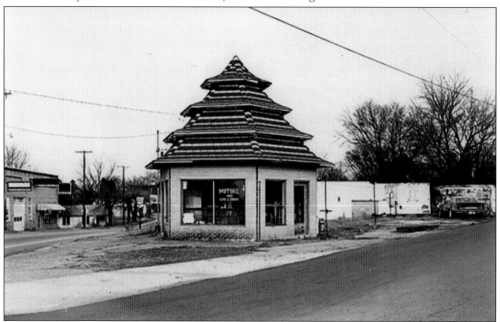

Just as many of the storied Highway 67 lodging places have disappeared in the age of the interstate, so have most of its dining establishments, with the coming of the era of bland fast-food outlets located by the interstate. The unique building seen here had been constructed to be a drive-in restaurant in the curve of U.S. Highway 67 on the western edge of the city. Abandoned by the time of this photograph, it was razed years ago. (Courtesy Donna Langston of Malvern.)

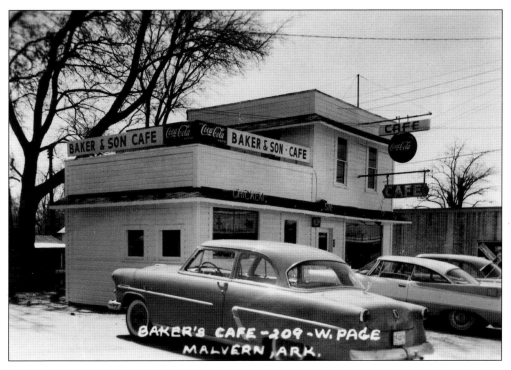

Dining options on the western edge of town included Baker and Sons Café, seen above around 1957. It opened originally as the Double Deck Café, owned by C. W. Hardwick and his sister Margaret Lee Hardwick.; it later sold to the Baker family. The business at 209 West Page Avenue later became a pawnshop, as seen below in this c. 2005 photograph by the authors.

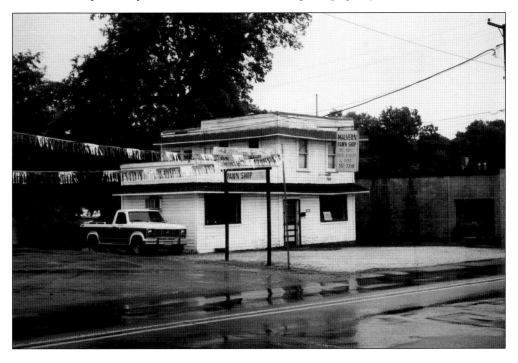

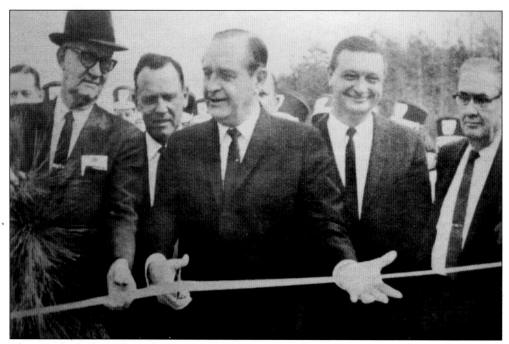

The proud role for U.S. Highway 67 as a route for thousands of cross-country motorists came to an end when Gov. Orval Faubus cut the ribbon opening U.S. Interstate 30 between Hot Spring County and Benton. A beaming Hot Spring County judge Neil Phelan is seen to the right of the governor.

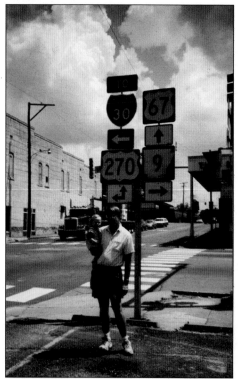

While it is true that for decades most of the traffic has been gone from U.S. Highway 67's path through Malvern and Hot Spring County, the road is still there. The intersection of Main Street and U.S. Highway 67 is framed here in 1999 behind Ray Hanley and his young son Joey. The building to the left that once housed the Elite Café is sadly an empty concrete slab today, but downtown Malvern remains worth a visit. While it is fast and easy to keep to the nearby U.S. Interstate 30, it is well worth a motorist's time to leave the four-lane for a few miles of travel on what might well be the "Mother Road of Arkansas."

Four

CITY OF INDUSTRY

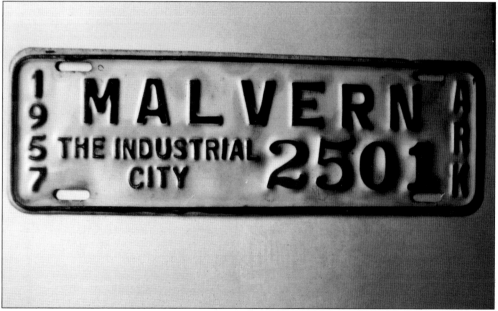

In the 1950s, the City of Malvern's chamber of commerce sold the license plate seen above to be displayed on the front of residents' cars. Purchase was voluntary and served as both a fund-raiser for the city and a way for residents to show pride in their hometown. Malvern, blessed with a wealth of natural resources in the surrounding area, earned and promoted a reputation as an industrial hub almost from its founding. Drawing on timber, farmland, and minerals, the industrious area thrived with lumber mills, brick factories, and by World War II, one of the world's largest aluminum plants.

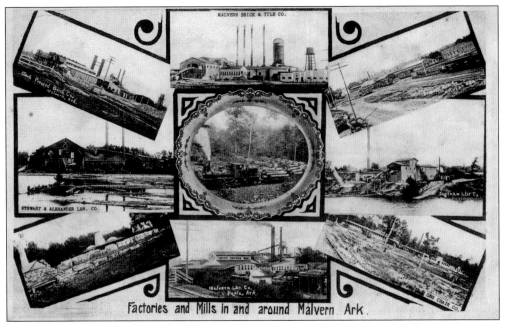

Malvern and its surrounding Hot Spring County showcased part of its abundance of natural resources on this collage postcard around 1908. Featured industries included the Clark Pressed Brick Plant, Malvern Brick and Tile, the Stewart and Alexander Lumber Company, Malvern Lumber Company, a brick kiln, and even a chair company that processed hardwood into furniture.

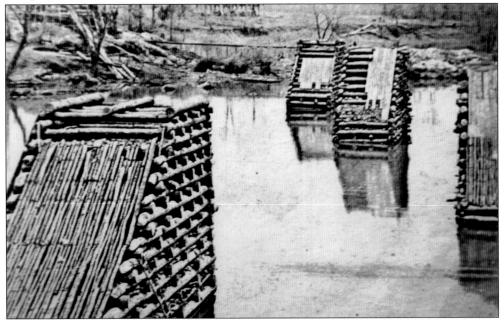

The first industry after farming to develop around Malvern was the extraction of vast tracks of virgin timber, both bottomland hardwoods and slopes covered in huge pine trees. In the 1890s, Rockport, the first settlement, looked out over this system of log structures that helped stop and hold timber that floated downstream. The logs were held in the water until pulled up on the shore for processing into lumber at an adjacent mill. (Courtesy HSC Historical Society.)

Cutting virgin timber in the wooded hills and bottomland around Malvern was hard labor in the era before chain saws. The team of men, seen here around 1918, were identified as Willis Dickinson on the left with the ax and a Mr. Myers on the right with a long two-man crosscut saw. One man who spent a lot of time in the logging camps, Lewis Wallace, said in later years that "Dickinson and his partner could cut more logs than anyone else." (Courtesy HSC Historical Society.)

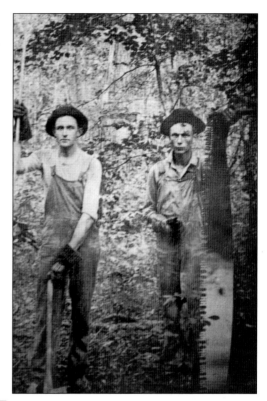

The studio-posed photograph of the well-dressed young man belied both his occupation and his untimely demise. One morning in 1927, the 29-year-old Bill Cunningham was working in his small sawmill near the Clear Creek community. He was caught in the flywheel of his saw and flung 20 feet to his death, evidence of the hazard of one of the dominant occupations of the day. Cunningham left a mourning wife, a 7-year-old son and a 16-day-old daughter who would never know her father. (Courtesy HSC Historical Society.)

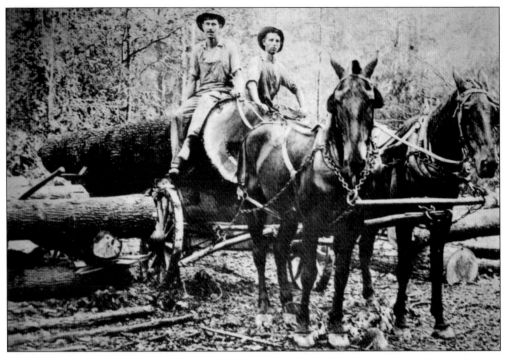

Today logs are taken from the forests by chain saws, tractors, and other labor-saving machinery. In the early years of the 20th century, it required instead the hard labor of both man and beast as well as adaptation of wagon wheels. These two men were preparing to literally ride a huge oak log either to a railhead spur or a local sawmill with the product of their labor. (Courtesy HSC Historical Society.)

Zeola McMullin posed with his team of mules after hauling a load of logs to the small sawmill near Donaldson. Small mills like this one were scattered throughout the county but would later be pushed aside by the massive reach of large lumber companies that bought up the available timberland. (Courtesy HSC Historical Society.)

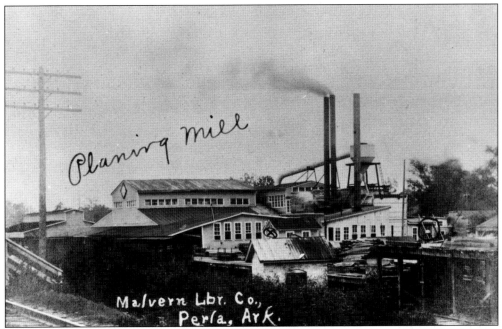

Adalbert Strauss, one of a number of German immigrants to become American lumber barons, built a sawmill just east of Malvern in Perla in 1880. Strauss formed the Malvern Lumber Company, which logged the flatlands of the coastal plain east and south of the mill. In 1904, Strauss formed the Perla Northern Railroad and pushed tracks deeper into the Ouachita Mountains to feed his sprawling mill with logs. (Courtesy Dr. Bill Pollard of Conway.)

The store seen here around 1910 sprang up by the tracks serving the employees of the Malvern Lumber Company mill. The buildings are long gone, as is the mill, but Perla remains an independent municipality adjoining the east side of Malvern. (Courtesy Dr. Bill Pollard of Conway.)

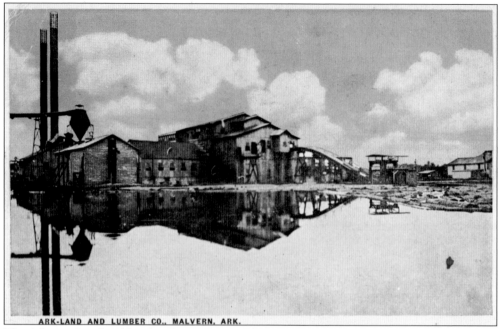

ARK-LAND AND LUMBER CO., MALVERN, ARK.

The Arkansas Land and Lumber Company owned 50,000 acres of timberland west of the Ouachita River, much of it in Hot Spring County. In 1914, the Wisconsin businessmen who owned the lumber company opened a new sawmill at Malvern to process its timber. The huge log holding pond, capturing the reflection of the sprawling mill, was the subject of this postcard in 1924. The mill closed in 1929, having cut all the timber within the company's reach.

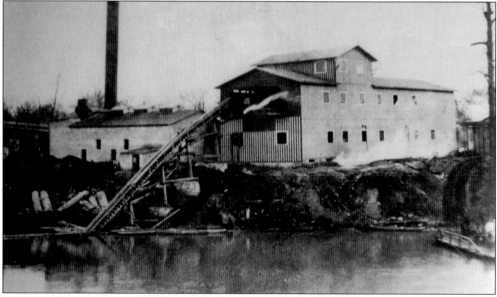

The Saginaw Lumber Company erected its mill on the banks of the Ouachita River west of Malvern in the 1880s. The company was forced to go out of business in 1912, having exhausted the timber it owned. It was foiled in its efforts to expand when the Arkansas Land and Lumber Company purchased the large blocks of timber adjoining the Saginaw properties. (Courtesy HSC Historical Society.)

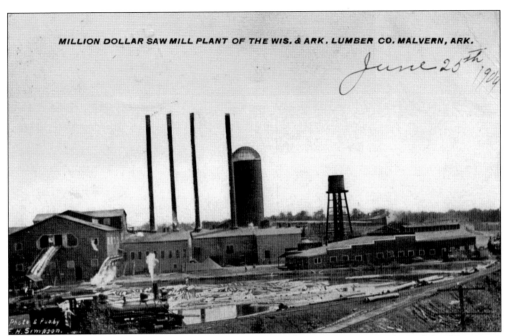

MILLION DOLLAR SAW MILL PLANT OF THE WIS. & ARK. LUMBER CO. MALVERN, ARK.

June 25th 1909

Perhaps the largest and most sustained lumber operation in Malvern was that of the Wisconsin and Arkansas Lumber Company; its mill is seen here on a 1909 postcard touting a $1 million investment. The principal owner was Arthur B. Cook who would operate it, along with Malvern Brick and Tile, until his death in 1934. His daughter Verna Cook Garvan would succeed him to be one of the nation's few woman CEOs of a large manufacturing concern. Garvan's donation of 210 acres outside of Hot Springs made the tourist attraction known as Garvan Gardens possible.

The operations of the Wisconsin and Arkansas Lumber Company, which came to be abbreviated as WALCO, included its own company store. A portion of the mill workers' pay sometimes came in the form of these tokens carrying the name of the lumber company and redeemable for goods only in the WALCO company store.

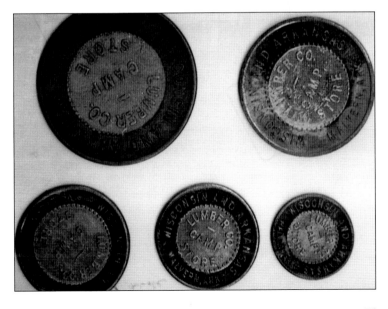

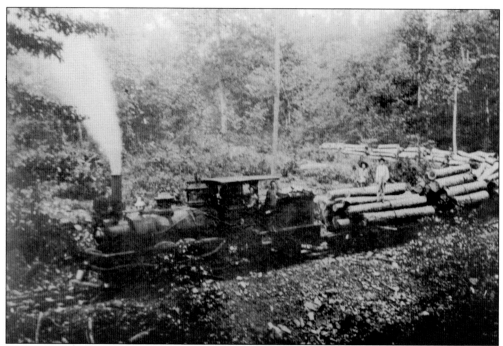

WALCO reached far into the thousands of acres of timberland it owned with railroads laid down for the express purpose of hauling out the logs to the massive mill at Malvern. The photograph above captured a view of only a part of the long string of cars loaded with logs, while the postcard below, around 1908, shows one of the trains parked at the mill. WALCO, along with the competitors that exploited the once-virgin forests of Hot Spring County, practiced unsustainable harvesting practices. "Cut and get out" became an industry term of the era, when little thought was given to sparing tracts of land for wildlife or future generations. Much of the cut-over land belonging to WALCO was eventually sold to the International Paper Company, which replaced what had once been diverse forests with pine plantations.

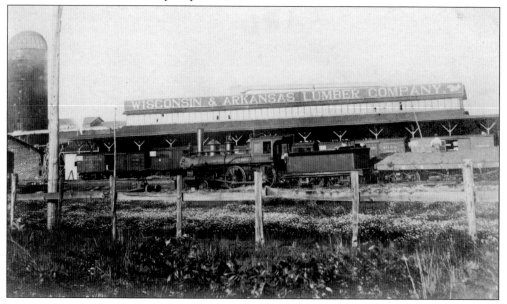

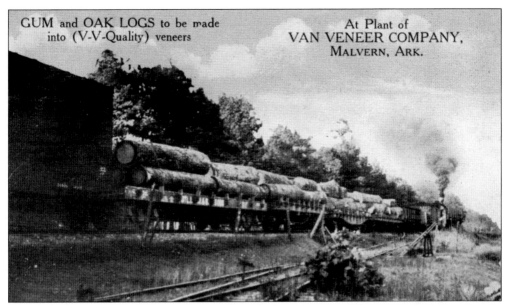

GUM and OAK LOGS to be made into (V-V-Quality) veneers

At Plant of VAN VENEER COMPANY, MALVERN, ARK.

The Van Veneer Company plant was an employer for many years in Malvern, turning many varieties of timber into products used for furniture and other goods. This 1914 postcard was mailed by the company to a potential customer in New York. The message read, "Send us your specifications for KILN DRIED ROTARY CUT VENEERS In Gum, Oak, Pine, Elm, Hickory, Basswood, and White Holly." The added typed message read, 'Can ship in mixed cards gum drawer sides, run in linel', grooved and nosed, let us quote on next order."

The Van Veneer Company is a story about a homegrown manufacturer but also the story of a family through the decades. Founded in the early 1900s by Harry A. Van Dusen, he would pass on the business to his sons, seen here around 1940. From left to right, Halley, Roy, and Ralph Van Dusen were standing in the log yard where the timber was stored until ready for the process of peeling the veneer for the finished product. During the 1940s, much of the veneer went into Philco radio cabinets and later into a variety of furniture. (Courtesy Janis West of Malvern.)

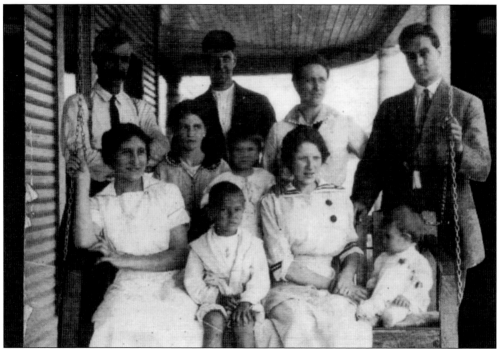

The Van Dusen home at North Main and Berger Streets was filled with activity over the decades, including a family portrait on the porch swing. From left to right are (first row, seated) Esther Van Dusen, daughter of Harry and Lillian Elizabeth; James A., son of Ralph E. and Aletheye; Aletheye Tantlinger Van Dusen, wife of Ralph; Millicent A., daughter of Ralph and Aletheye; (second row, standing) Elizabeth Mae and Ralph Tantlinger, both children of Ralph and Aletheye; (third row, standing) Harry A. Van Dusen, father of Ralph, Esther, and Roy; Roy Van Dusen, son of Harry and Lillian; Lillian Elizabeth, wife of Harry and mother of Ralph, Esther, and Roy; and Ralph Earl Van Dusen, son of Harry and Lillian and husband of Aletheye. Below, the family had gathered in the yard around the automobile that Elizabeth's mother, Lucina Emyle Weitz Stoops, owned and for which she had a paid driver. (Courtesy Janis West of Malvern.)

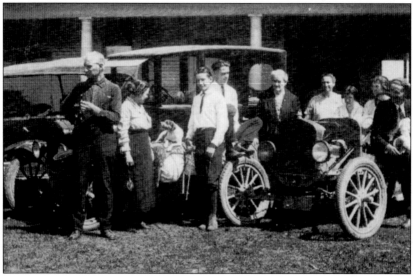

The Van Dusen home hosted many family gatherings over the years, including the reunion seen above. Below the home is seen in the 1940s; it still stands, though altered somewhat, at North Main and Berger Streets. (Courtesy Janis West of Malvern.)

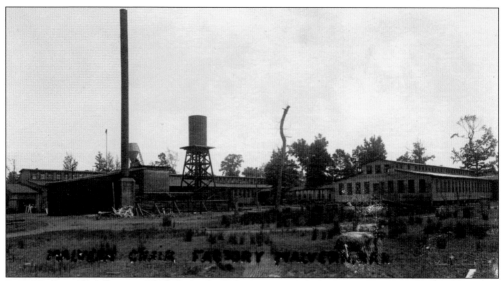

R. B. Harper of Malvern mailed this postcard around 1910 penning, "This a picture of the chair factory but it is not a very good one but is the best view I could get of it." Not all the hardwood timber taken from the forests surrounding Malvern went into lumber but rather into furniture like the chairs produced in Malvern Chair Factory.

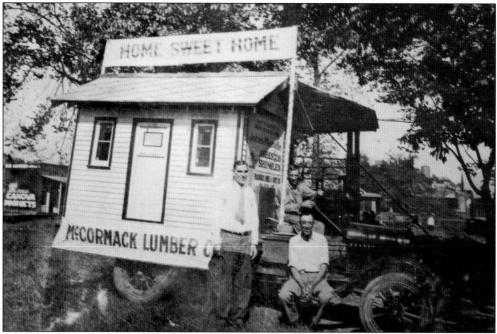

Lumber was still selling well during the booming 1920s. Certainly the McCormack Lumber Company was doing well enough in 1927 to enter this promotional float into the parade for the Hot Spring County fair. The second place prizewinner was photographed on the courthouse lawn and displayed products sold by the business such as lumber, paint, shingles, windows, and so on. Bookkeeper Hoyt Willians is standing; seated on the running board was Claude Carver, who operated a planer. Part-time Assembly of God preacher Johnny Thompson was the driver. (Courtesy HSC Historical Society.)

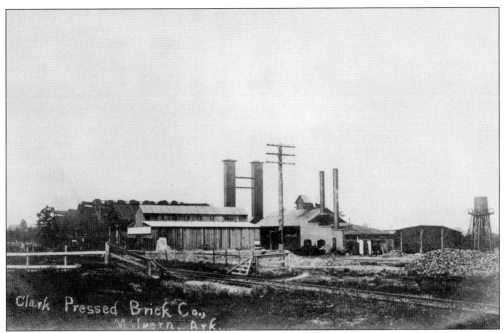

The rich clay deposits in the Malvern area, especially around Perla just east of the city, gave rise to brick making in the 1890s. One of the early plants, seen here in 1907, was the Clark Pressed Brick Company. The other large brick maker at the time was Malvern Brick and Tile, owned by Arthur B. Cook, who also controlled the Wisconsin and Arkansas Lumber Company.

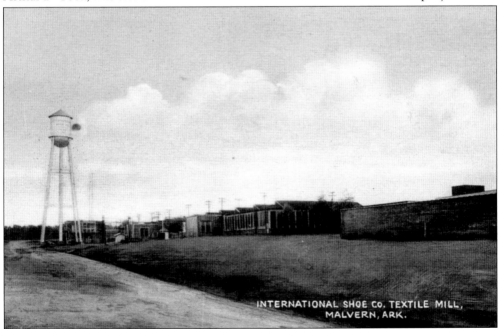

Over the decades, hundreds of Hot Spring County residents earned a living making shoes at the North Malvern plant of the International Shoe Company. Today almost all the manufacturing of shoes has moved overseas to low-wage, third world nations; the site of the old factory is today home to a vocational college.

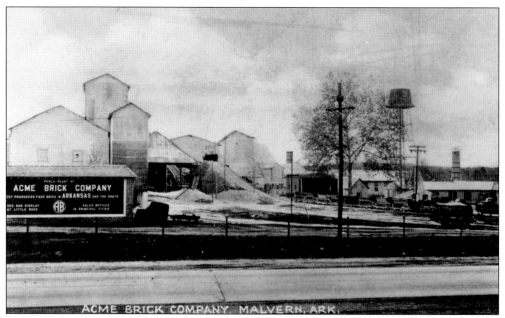

Acme Brick, pictured here on a *c.* 1940 postcard, bought 120 acres of rich clay acreage in Perla on the edge of Malvern in 1919 to build a brick plant. The first bricks were shipped two years later, and a second factory soon followed.

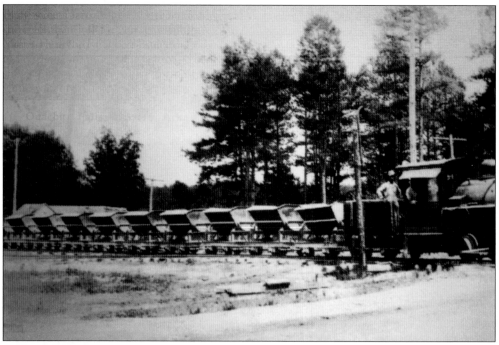

In this 1925 image, a small train hauls carts of clay from the clay pits at Perla. By 1929, Acme had three plants operating at Perla and one in Malvern. Today Malvern bills itself as the "Brick Capitol of the World." Each year since 1981, on the last weekend in June, the city hosts "Brickfest." Activities include a brick toss, a brick car derby, and a best-dressed brick contest. (Courtesy HSC Historical Society.)

The Remmel Dam built by Harvey Couch in 1924 formed Lake Catherine and generated electricity for the community. The dam had a major impact on the nation's war effort in the 1940s and helped create the best-paying jobs Hot Springs County had ever envisioned.

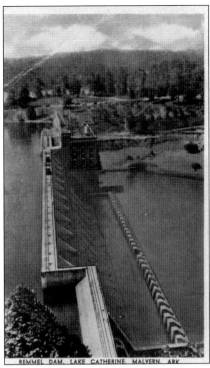

REMMEL DAM, LAKE CATHERINE, MALVERN, ARK.

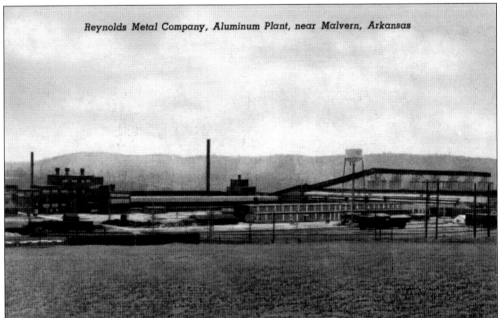

Reynolds Metal Company, Aluminum Plant, near Malvern, Arkansas

During World War II, Arkansas's production of bauxite, the basic mineral used to produce aluminum, increased 12-fold. Taking advantage of the ready source of power at Remmel Dam, the federal government built an aluminum production facility at Jones Mill, adjacent to the dam, leasing it to Alcoa for production of the metal needed for war. After the war, Alcoa sold the plant to Reynolds Metals, which operated it until 1985. Citing cheaper production costs elsewhere, Reynolds closed the facility in 1985, wiping out 1,400 high-paying jobs.

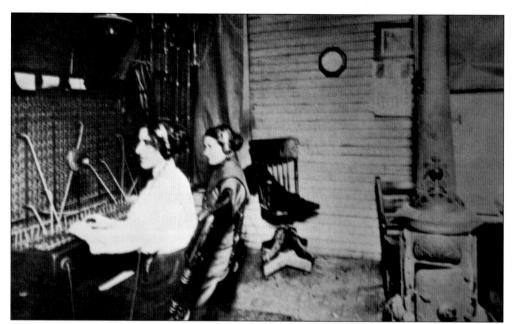

Communication with customers around the nation would prove vital to selling the manufactured products of Hot Spring County. When E. H. Frisby opened Malvern's first telephone exchange on March 27, 1898, it had 60 subscribers. Two women were employed as switchboard operators. Six months later, in response to public demand for service, which would reach beyond the city limits, additional equipment was installed, enabling the local exchange to connect with the Bell telephone system's long distance lines. Nighttime service was also added. In 1904, six years after opening the exchange, E. H. Frisby formed a local stock company, incorporating it under the name Malvern City Telephone Company. Pictured below, the new company's first act was to move the telephone exchange out of the business district to a building near the residential section.

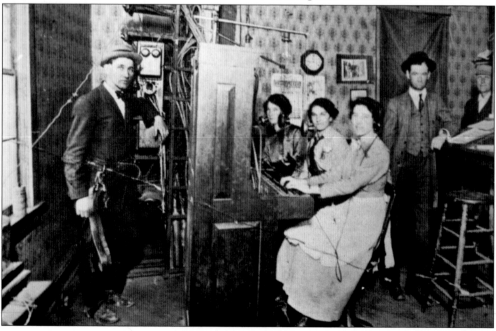

Five

THE PRESIDENT COMES TO TOWN

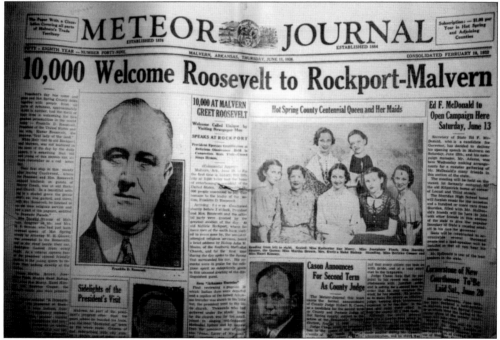

The *Meteor Journal* newspaper estimated that 10,000 people turned out to see the president and first lady. It was the largest crowd in the history of Hot Spring County. Congressman John L. McClellan (bottom of page), who had personally invited FDR to Rockport and Malvern, accompanied him that day. McClellan had moved to Malvern and opened a law practice in 1919. His political career had begun when he was chosen Malvern city attorney in 1920. Elected to the U.S. Senate in 1942, McClellan would serve for 35 years, longer than any other Arkansan.

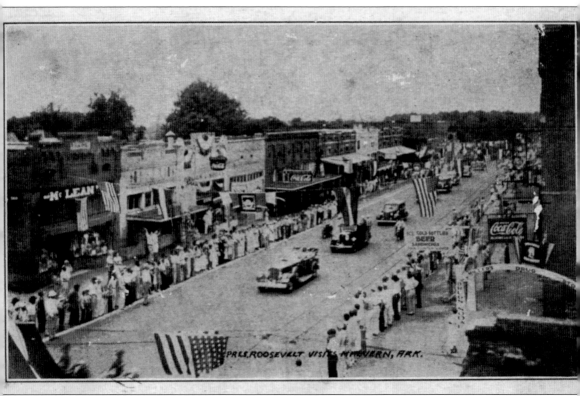

From Rockport, the Roosevelts proceeded to Malvern. Flagpoles, flying American and Arkansas flags, lined both sides of the roadway for 2 miles. Riding in an open-topped Packard automobile, the president and first lady smiled and waved (above) as they led a parade down Malvern's Main Street. American flags hung from McLean's Department Store and over the street. Note the two Coca-Cola signs, one on either side of the street, and the "Ice Cold Beer" sign on the right next to Miller's Drug Store. FDR's train was waiting at the depot to depart for Little Rock.

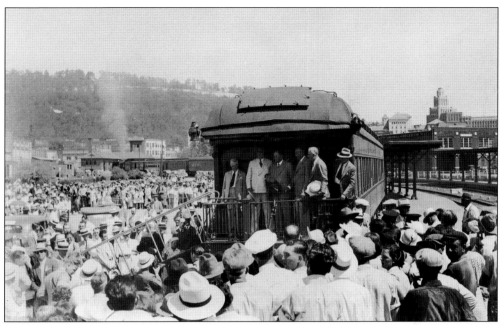

Pres. Franklin D. Roosevelt and the first lady visited Arkansas on Wednesday, June 10, 1936. Their one-day visit marked the opening of the state's centennial celebration. A huge crowd greeted the first couple when their train arrived at the Missouri-Pacific Depot in Hot Springs. One farmer told the *Sentinel Record* that he had ridden his mule over 30 miles of rough mountain roads for the once-in-a-lifetime opportunity to see the president. Note the ramp with hand rails. As a polio victim who could not stand without braces nor walk without crutches, FDR was a leader in the nation's fight against the crippling disease. The American public, however, did not realize the full extent of his disability.

After visiting the Army-Navy Hospital, the presidential party rode to Couchwood, the lakeside home of Harvey Couch, the founder of Arkansas Power and Light. Couch was chairman of the Arkansas Centennial Committee. Following what was billed as an "Arkansas Traveler Dinner," the dignitaries headed to Rockport to attend a historical pageant and outdoor religious service at the Rockport Methodist Church. All along their announced route, people waited patiently in the summer heat to get a glimpse of the president and his wife. The road from Hot Springs to Rockport had been paved just for the occasion and almost every structure bore a fresh coat of paint. Due to limited funds, however, only the sides of the buildings facing the road had been painted.

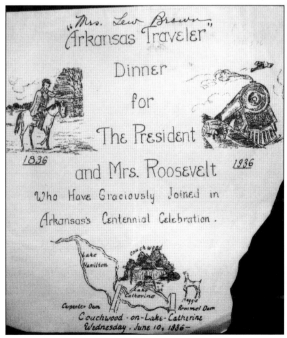

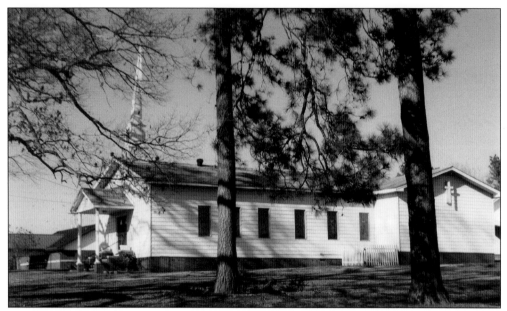

Speaking at the conclusion of the religious service that followed the pageant, FDR reminded his listeners of the importance of religion in the country's history. "It seemed to be in our American blood," he said. "And so as the nation developed and as men moved across the Alleghenies and across the Mississippi, religion went hand in hand with them. I am glad that in these more recent days, the spiritual qualities of the American people are keeping pace with the more material civilization." Like the state, Rockport Methodist Church was celebrating its centennial. The present structure (above) still has the original log framework. Today a historical marker commemorates the occasion. (Photograph by Ray Hanley.)

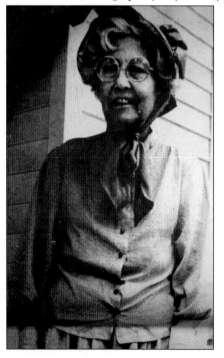

Eudora Fields posed for this photograph in June 1986, wearing the dress that she had worn 50 years earlier when Pres. Franklin D. Roosevelt visited. Fields had a long career as a teacher and school administrator in Malvern.

Six

PREACHING, TEACHING, AND GOVERNMENT

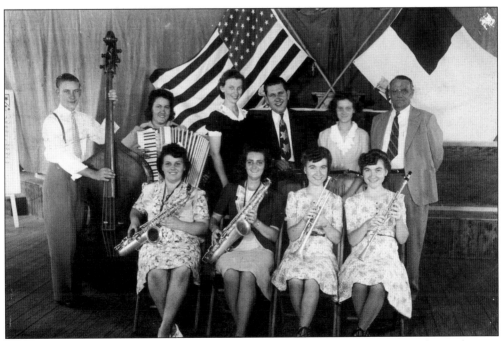

An integral part of the history of Malvern and Hot Spring County is woven into the area's many churches, schools, and the local government elected by the area citizens. The North Malvern Assembly of God Church has long anchored a spot on North Main Street. This group of well-equipped musicians in the 1950s was part of the congregation. They included, from left to right, (first row) Vashti VanBiber, Mildred Patrick, Ruth Erwin, and Ruby Erwin; (second row) Junior Davis, Della Davi, Ruby Davis, Donald Davis, Virginia Patrick, and Rev. William C. VanBiber.

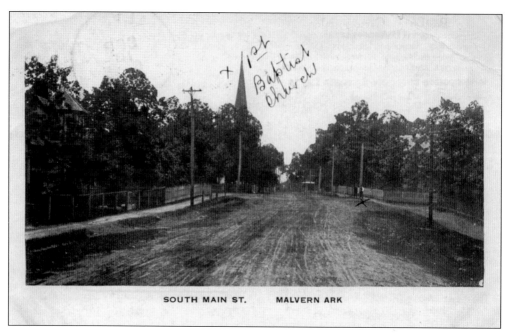

SOUTH MAIN ST. MALVERN ARK

When the Malvern Baptist Church (now First Baptist Church) was destroyed by fire in the 1880s, this new house of worship was erected on property out on South Main Street, its steeple marked on this 1907 postcard looming in the distance over the dirt Main Street. The church traces its roots to 1878, when New Prospect Baptist Church consolidated with Rockport Baptist Church and moved to Malvern. The sender of the card penned, "This is the residence part of South Main, it looks better now that the sidewalks have been concreted and the street graded." The church lost its steeple in a 1909 tornado and rebuilt as shown below. Today First Baptist Church worships in an imposing white-columned sanctuary located on South Main Street.

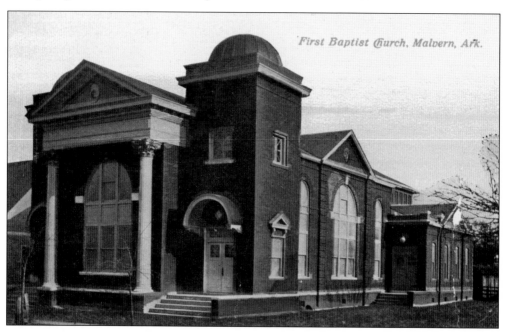

First Baptist Church, Malvern, Ark.

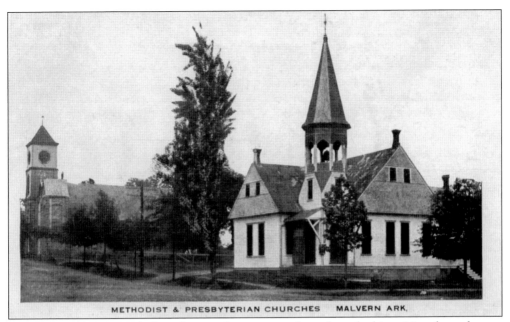

METHODIST & PRESBYTERIAN CHURCHES MALVERN ARK.

Church steeples were, aside from the courthouse tower, about the only thing rising above the tree line in Malvern in the first decade of the 20th century. The 1907 postcard above captured both the Methodist and the Presbyterian churches. Both faced dirt streets but had rough sidewalks that would have lead a stroller between the two houses of worship.

IN LOVING
REMEMBRANCE OF

Evangelist Millicent E. Goss,
Born Oct. 30, 1883.
Died Aug. 18, 1910.
Age 26 yrs. 10 mos. 14 days.

GONE BUT NOT FORGOTTEN.

'Tis hard to break the tender cord
 When love has bound the heart,
'Tis hard, so hard, to speak the words,
 "We must forever part."
Dearest loved one, we must lay thee
 In the peaceful grave's embrace,
But thy memory will be cherished
 'Til we see thy heavenly face.

Not all the ministering in Malvern a century ago was done by men. The founder of the local Apostolic Faith church died at the age of 26 of complications from childbirth, leaving behind a 3-day-old daughter. Her obituary in the local paper read in part that she had "unexpectedly been called to the great beyond."

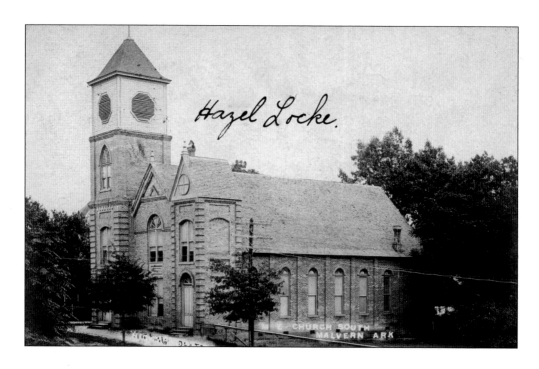

Known at the time as M. E. Church South, the predecessor of Malvern's First Methodist Church was a handsome towering brick structure at what is today East Page Avenue. Established in 1878, the church was an outgrowth of the pioneer Rockport Methodist Church. The striking house of worship was in the path of a 1909 tornado that left only the front facade of the building standing. The same storm also destroyed the Presbyterian church seen on page 91 in 1907.

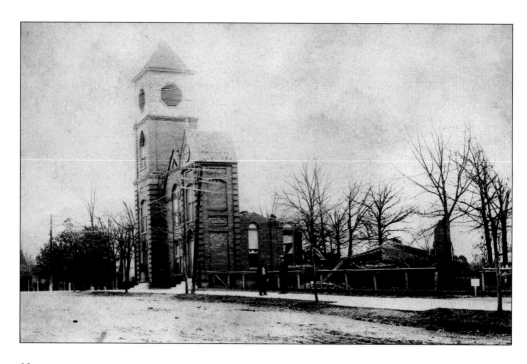

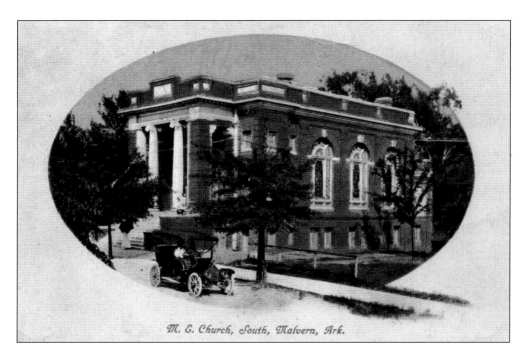

M. E. Church, South, Malvern, Ark.

Completed in January 1910, this white-columned brick building on East Page Avenue was the new home of Malvern's First Methodist Church, whose previous house of worship had been lost to a tornado a year earlier. The land adjacent to the house of worship was sold to the federal government in 1934 for $4,000. A new post office (below) was soon under construction. Thirty-two years later, in 1966, the property was purchased by the church for $25,000. The old post office was incorporated into the church and converted into a chapel and classrooms; it is still in use.

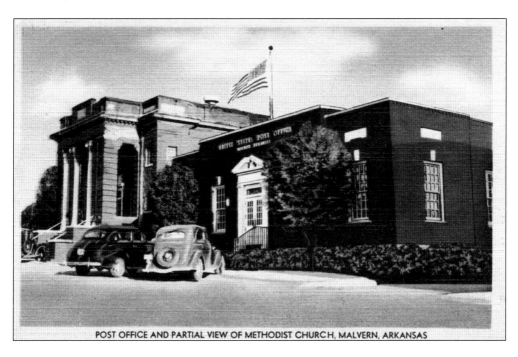

POST OFFICE AND PARTIAL VIEW OF METHODIST CHURCH, MALVERN, ARKANSAS

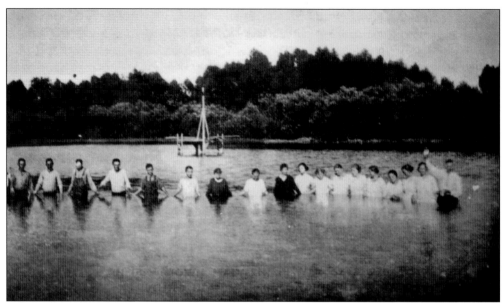

Today many churches have temperature-controlled baptisteries within the confines of their sanctuaries. In the first part of the 20th century, however, most of those who made their professions of faith within Hot Spring County churches were baptized in local streams, very often the Ouachita River. The unusually large number of new Christians were preparing to undergo the rite in the river at Grigsby Ford around 1940 with Rev. John Clem performing the baptizing. (Courtesy HSC Historical Society.)

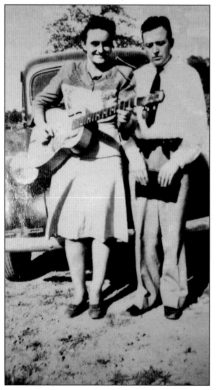

The husband and wife team of Assembly of God evangelists W. V. Grant and wife Lorene's work involved establishing several new churches. They posed here in Hot Spring County in the early 1940s, armed with a guitar and well-thumbed Bible. (Courtesy Pauline Reynolds of Malvern.)

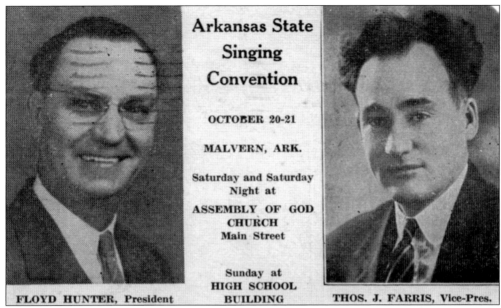

Arkansas State Singing Convention

OCTOBER 20-21

MALVERN, ARK.

Saturday and Saturday Night at
ASSEMBLY OF GOD CHURCH
Main Street

Sunday at
HIGH SCHOOL BUILDING

FLOYD HUNTER, President THOS. J. FARRIS, Vice-Pres.

Malvern played host to the Arkansas State Singing Convention in 1949, first at the Assembly of God Church on Main Street and then on a Sunday at the auditorium of the high school.

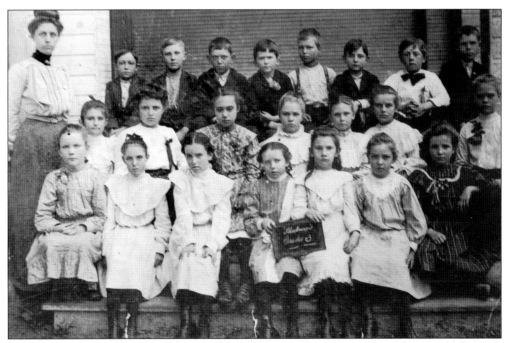

Most children in Malvern attended Sunday school year-round, but in the early years of the 20th century, there was no law requiring compulsory school attendance. These Malvern children however, wearing their best clothes, were in the city's elementary grades around 1910. Their teacher, seen to the left, would have earned $273 for a 107-day school year if paid the state's average for the time.

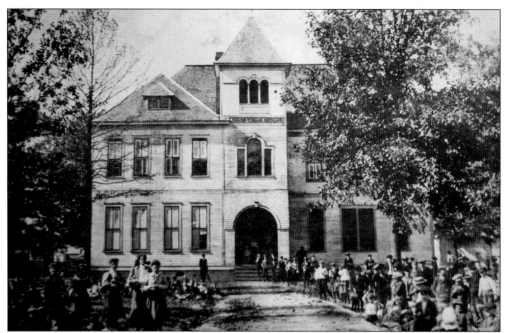

Malvern first obtained school district status in 1881 and opened a two-story frame school on Sullenberger Street; the school burned down in 1897. The new school is seen above; it cost $3,169 to construct. The student body posed on the school lawn around 1900. At the time, Malvern was one of some 5,000 school districts in Arkansas, and teachers earned an average of $150 for a 69-day school year.

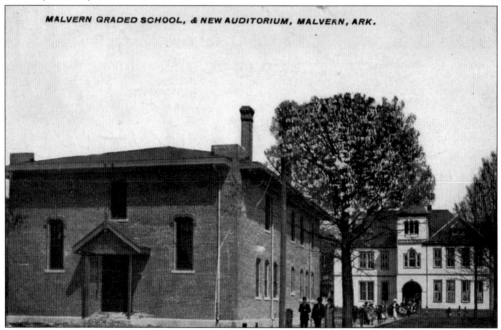

MALVERN GRADED SCHOOL, & NEW AUDITORIUM, MALVERN, ARK.

By 1910 when this postcard was mailed, the Malvern "graded" school had acquired a new brick structure for classes that was constructed for $6,174 in 1909 in front of the older 1897 building on South Main Street. In 1910, the State of Arkansas invested $12 per child per year in supporting education.

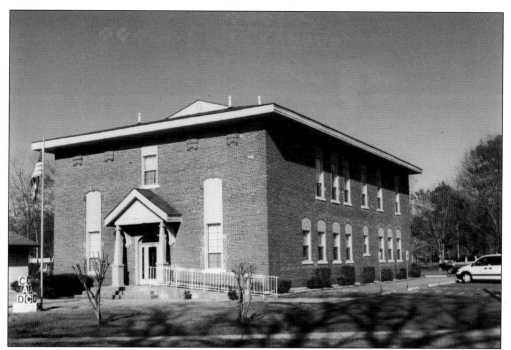

A century later, much has changed on the educational front in Malvern, but the brick building that helped teach children in the 1910 postcard is nicely restored. It houses the operations of the Central Arkansas Development Council, a non-profit agency. (Photograph by Ray Hanley.)

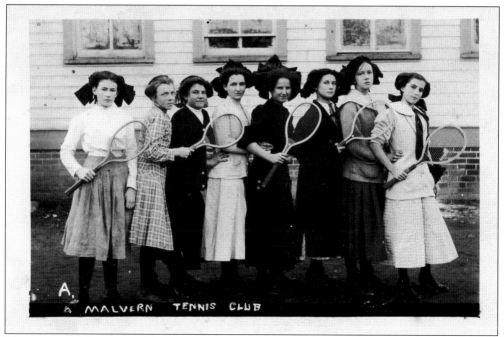

Physical education was a part of teaching the mind and body for Malvern students around 1910. These young ladies, poised beside the school, were members of the school's tennis club.

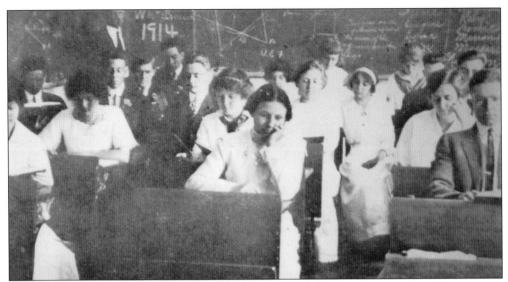

Likely trying to look studious, the Malvern High School class of 1914 posed at their desks before open lessons. Official school rules at the time prohibited students from "the use of profane or unchaste language" and continued, "the use of tobacco or gum is strictly forbidden. Any pupil smelling of tobacco shall be sent home to disinfect. Every pupil will be held strictly accountable for his own seat and desk, and must answer for any abuse or damage it may receive." (Courtesy HSC Historical Society.)

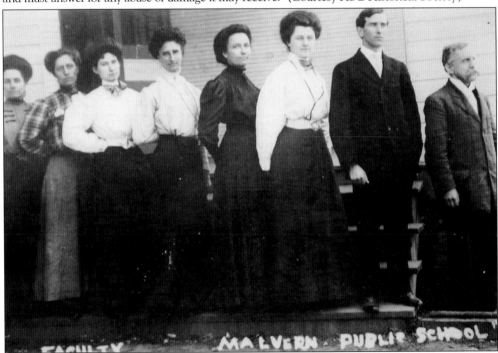

The Malvern public school faculty posed around 1912, when state records reflect there were fewer than 10,000 teachers in all of Arkansas. Most Arkansas teachers at the time had a state certificate but not a college degree. The state's first college dedicated to training teachers, the Arkansas Normal College, opened in Conway in 1907; it is today the University of Central Arkansas. (Courtesy HSC Historical Society.)

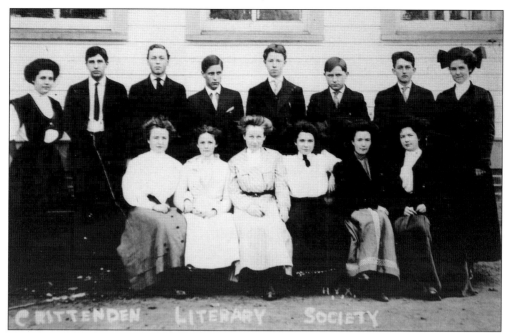

Around 1910, the Malvern High School Crittenden Literary Society posed for a photograph. They were also part of a debating team. Standing from left to right are Alend Burwell, Jim Alderson, Rex Honeycutt, Robert Freeland, Clyde Honeycutt, William Murry, Marvin Keith, and Linnie Glover. The club was named for the man who had been the first secretary and the first acting governor of Arkansas Territory in 1820.

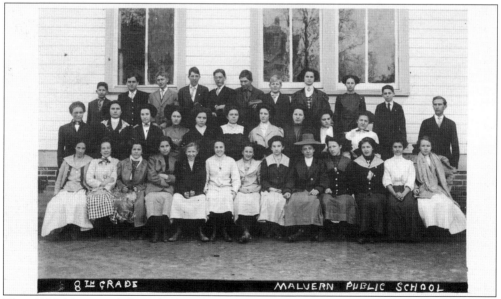

The 1910 Malvern eighth grade class posed, likely in their best clothes, beside the school along with their teacher. The card's penned message said, "I am going to a banquet tonight at the W. O. W Hall. Please don't let anyone see this picture for it is a sight but I will tell you the reason we look so sad. You know examinations make us pale." Arkansas had only enacted its first compulsory school attendance law in 1909.

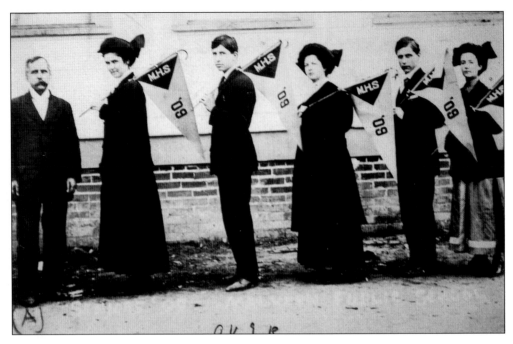

A far lower percentage of students completed 12 grades of education a century ago than in today's society; hence, graduation photographs were prized for the small classes in Malvern. Above, a few of the seniors of 1909 posed with pennants, while below, a rather somber group posed on the school steps around 1910. One of the school rules in the handbook for these students was that "there will be no special courtesies between the sexes in passing to and from school."

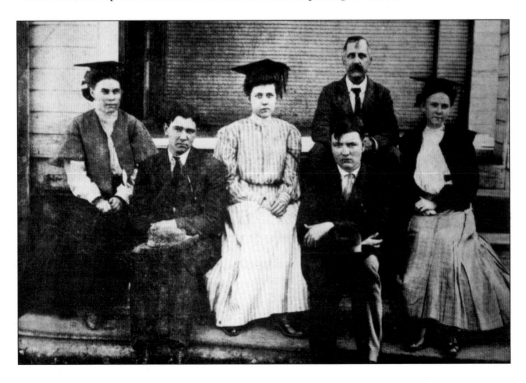

Rockport, on the northern outskirts of Malvern, educated its children in a rambling white-frame wooden building that was heated in winter by at least four fireplaces. The entire student body, all grades, posed within the school yard in 1912. The notes on the back of the photograph identify a student in the second row as Eudora Nuesch, who would later marry a Mr. Fields. The young woman would grow up to be an educator and eventually the principal of the elementary school in North Malvern that would bear her name upon her retirement. Fields is seen on page 88 some 74 years later. (Courtesy HSC Historical Society.)

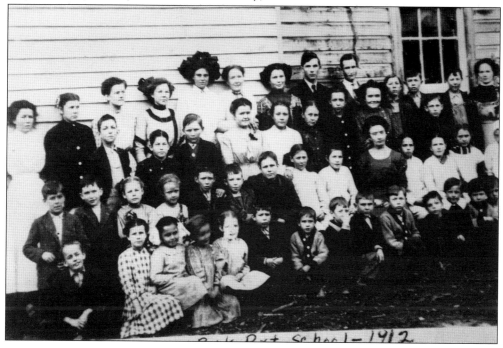

Some came from distant places to leave their mark on Hot Spring County's schoolchildren. Born in Pennsylvania in 1825, William D. Leiper came to Arkansas in 1856, settling in the Dallas County hamlet of Tulip. With the outbreak of the Civil War in 1861, he enlisted in the Confederate army and saw combat in several battles. At the close of the conflict in 1865, he was discharged with the title of brigadier quartermaster. (Courtesy HSC Historical Society.)

In 1877, William Leiper moved to Malvern, becoming a merchant and publisher of Malvern's *Meteor Journal*, the town's newspaper. He also served as superintendent of the city's schools for over four years and was later appointed county superintendent for Hot Spring County, a position he held until his death in 1917 at the age of 92. (Courtesy HSC Historical Society.)

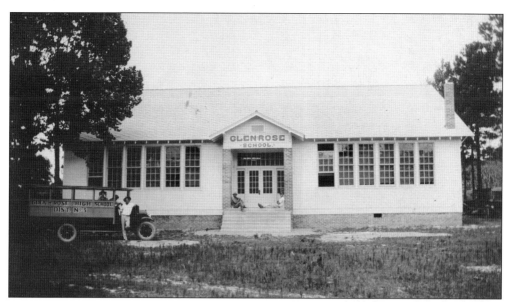

East of Malvern, on U.S. Highway 67, the Glen Rose School District was the place to learn the "three Rs" (reading, writing, and arithmetic) for many of the rural farm children in the area. The small school is seen here around 1930, its open-air school bus parked in the front. At the time, the average annual salary for an Arkansas schoolteacher was $691 for a 149-day school year. Today the Glen Rose campus is home to a group of attractive, modern buildings.

Sports were important even in the small schools that could not field a football team. Robbie Otts posed in her school athletic uniform around 1940, perhaps in the family's yard, before heading to school. (Courtesy of Pauline Reynolds of Malvern.)

"June Television Coming in Strong," appeared on page one of the *Malvern Daily Record* in 1931. The imagery reflected a timeless view of a child's imagination as the school year nears the summer vacation break. Television as a home entertainment appliance was some 20 years away, but the term was well used in the signals the young boy was receiving.

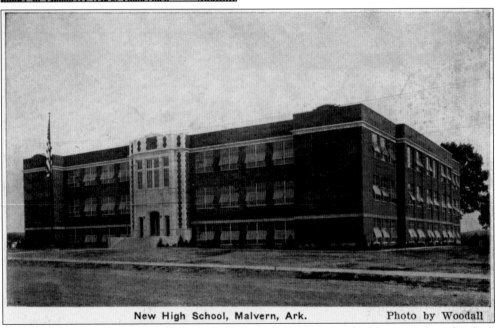

New High School, Malvern, Ark.　　　　　Photo by Woodall

The following postcard message was written in 1927: "This is a nice building just got it finished, this is the first year of school in it." The message referred to the brand new high school building for white students that had recently opened with a construction cost of $150,000. In 1927, the average Arkansas schoolteacher earned $597 for the year. The building would serve until replaced in the early 1970s, after which it was razed.

A few miles west of Malvern on U.S. Highway 67, the central school district was formed to serve the rural families of the area. At the time, the average Arkansas teacher earned only $594 for a 159-day school year. Below, the photograph captured the class of 1941's Central High School Student Council. In the first row were, from left to right, Chrystelle Finley, Margene Evans, Ruby Goodman, and Chlodine Hickman; (second row) Elmer Bashaw, Joseph Petray Jr., and L. Q. Cole. One boy is unidentified. Their sponsor Conway Keeton is in the back. The school district and the building are gone today, consolidated with other schools. (Courtesy HSC Historical Society.)

One of the stipulated promises in the Malvern public school regulations was that "pupils neither absent nor tardy during the school year will receive an honor certificate for the same from the School Board." Not many of these were awarded, but one that was prized for decades in her keepsakes was awarded to Martha K. Tyler, signed by principal J. L. Pratt and teacher Mrs. V. W. Belote at the end of the 1924–1925 school year.

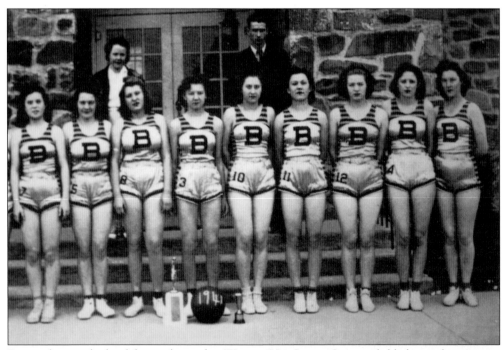

Bismarck, a rural school district located in Western Hot Spring County, fielded a trophy-winning girls basketball team in 1941. Today the still-rural district serves some 1,000 students in grades kindergarten through 12. (Courtesy HSC Historical Society.)

For more than 20 years, Pauline Jones was the face of high school algebra for thousands of students. Jones, photographed here for the 1956 yearbook, was known not just for her gifted teaching skills but for consistently wearing combinations of red and gray. The stories about why she chose those colors were a topic of conversation among students, at least before they realized they had better learn algebra regardless of the teacher's attire.

Jones, in addition to being a wonderful teacher, from whom one of this book's authors learned algebra, had a quirky sense of humor. Seen here, she posed for the opening page to the faculty section of the 1957 Malvern High School yearbook. (Courtesy James and Carolyn Batts.)

Larry Brashers (to the left) and Phillip Nix (below) were standout basketball players for the Malvern High Leopards in 1956. Brashers (class of 1956) would go on to medical school, while Phillip Nix (class of 1957) would go to dental school. Both would return to Malvern to provide medical care to a large segment of Hot Spring County residents. (Courtesy James and Carolyn Batts.)

The 1957 Malvern Leopard football team was supported by a cast of attractive cheerleaders, seen here posed in the school auditorium. (Courtesy James and Carolyn Batts.)

The honors of "Cutest Couple" for the 1957 Malvern High yearbook went to Eulavene Beason and Ray Clem. (Courtesy James and Carolyn Batts.)

Cutest
EULAVENE BEASON
RAY CLEM

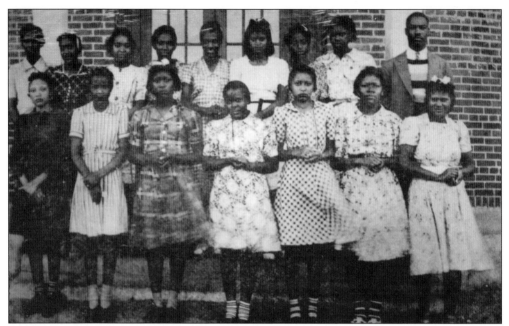

Like most southern communities, Malvern operated a segregated school system into the 1960s. In response to protest by African American citizens, the school board hired a new principal, Emma Peyton, before the opening of the 1939–1940 school year. During her administration, a hot lunch program was established. Her slogan was, "It's not my school. It's not your school. It's our school." These students posed with their teacher Hiram Tanner the year that Emma Peyton became principal.

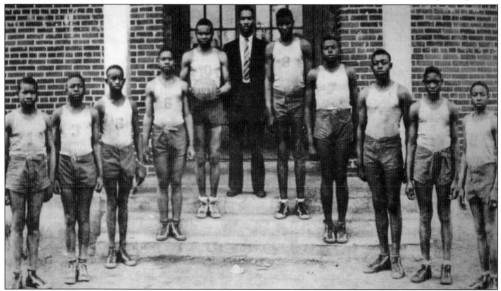

Teacher Hiram Tanner was hired at the same time as principal Emma Peyton. Known as an all-around athlete, the Philander Smith College graduate organized and coached the school's first basketball team. Because the school only offered grades one through nine, students had to leave Malvern if they wanted to attend high school. Thus some black families moved elsewhere or sent their children to live with relatives. Finally in 1952, the school district opened the Annie M. Wilson High School for black students. Malvern desegregated its schools in 1968. (Photographs courtesy HSC Historical Society.)

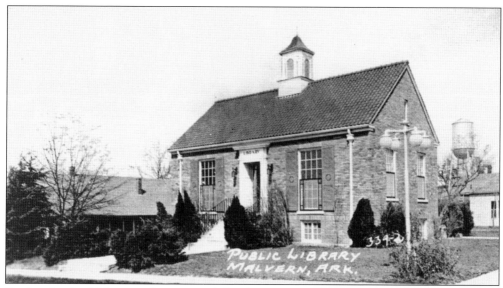

For decades, few Malvern students succeeded without many trips to the Hot Spring County Library. This colonial-style building housed the first Hot Spring County Library. Located at Third and Ash Streets, it was built and furnished through the efforts of the Women's Club of Malvern. When it opened in March 1928, it served as both a library and the women's club meeting place. The first paid librarian, Agnes Vaughan, earned $4 a month. Total cost, including grounds, building, and furnishings, was approximately $12,000. The structure, along with a later addition, burned in 1998. A new modern, much larger library sits on the spot today.

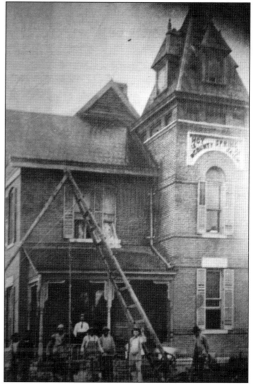

Not all Hot Spring County services were as open and friendly as the schools and library. A new Hot Spring County Jail was built in 1892. The sheriff and his family were housed in an annex attached to the red brick structure. The sheriff fed the prisoners on a fee basis. A new well was being bored in the front yard when this photograph was taken around 1911. Note the gasoline engine used to power the drilling rig at the foot of the ladder. Sheriff Richard S. Worley is standing on the porch. Elected in 1910, he served until December 1913 when he was killed in an automobile accident. (Courtesy HSC Historical Society.)

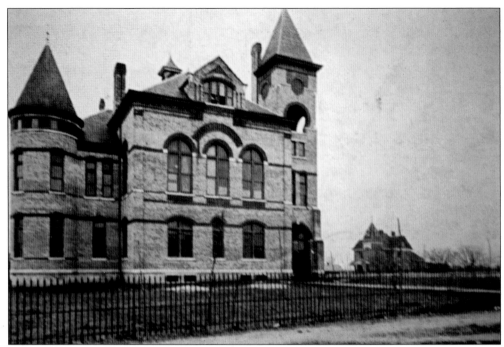

Following years of debate and delay, bids for construction of a new Hot Spring County Courthouse were taken in 1887. The Casey and McDowell Company won the contract with a bid of $16,150. This stately Victorian edifice was ready for occupancy by August 1888. The building in the distance on the right was the county jail shown on page 111. The unique structure was torn down in 1936 when the Works Projects Administration built the present county courthouse.

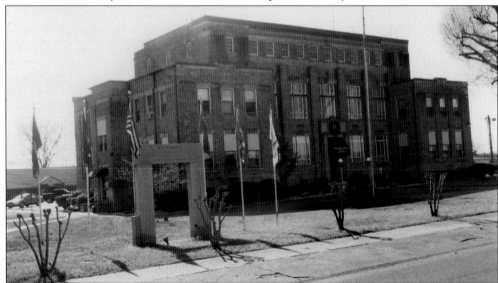

The old Hot Spring County Courthouse met the fate of far too many Arkansas courthouses in the WPA era; it was torn down to build a much blander facility. Opened in 1936, the new courthouse also housed the jail on the third floor, as the jail had been torn down along with the old courthouse. The building was constructed with bricks manufactured in Malvern and still serves the county. (Photograph by Ray Hanley.)

Seven

PEOPLE AND THEIR STORIES

The history of Hot Spring County and of Malvern is not just about its buildings, streets, and industries, but is very much about the people who erected the town and the descendants who followed in their paths. In this *c.* 1942 photograph, Arkansas governor Homer M. Atkins and his wife, Estelle (on the right), posed with friends Milton Kidder, owner and operator of Malvern's Kidder Funeral Home, and Mae Klostermeyer. Klostermeyer and her husband, Fred, owned a grocery store in the Social Hill community. Governor Atkins owned a farm there which he called "Sleepy Hollow." Atkins was the second Hot Spring County resident to become governor. James S. Conway of Magnet Cove was the state's first governor. He was elected in August 1836 following Arkansas's admission to the Union as the 25th state.

Cletis Odell Overton was born in a log cabin near the rural Hot Spring County hamlet of Willow in 1920. As a teenager during the Depression, Cletis worked for the CCC at the age of 16. In 1940, over his parents' reservations, Cletis enlisted in the U.S. Army and hitchhiked to Camp Robinson. He found himself stationed in the Philippines on November 7, 1941, where he learned of the attack on Pearl Harbor by the Japanese. He knew he and his comrades were war bound. Cletis was captured with thousands of other Americans and endured the Bataan Death March and 29 months of imprisonment and starvation. He watched many comrades die from disease, starvation, and execution. With the U.S. forces closing in by 1944, the Japanese put the surviving POWs on the *Shinyo Maru* bound for Japan. Unaware it carried POWs, an American submarine sank the vessel. Of the 750 POWs onboard, only 83 survived. After 13 hours of swimming, Cletis and a handful of survivors found land and rescue.

Cletis came home to Malvern and married his fifth grade sweetheart, earned two degrees, and made a success of life. Today at the age of 90, Cletis Overton lives in Malvern with a lovely garden and the gratitude of his nation. (Photograph by Ray Hanley.)

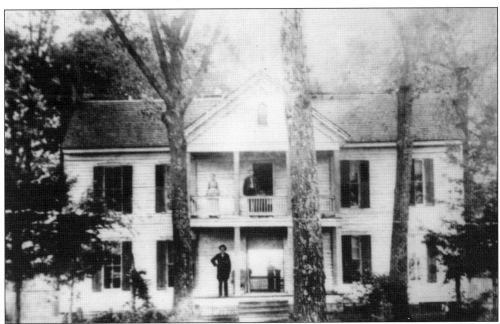

Built before the Civil War, this house was constructed of rough-hewn oak logs. By the time of this photograph, the walls had been boarded over. John Miller purchased the property in 1865, and it became known as "Miller's Dale." Note the open dogtrot in the center of the structure. On hot summer days, the family could rest in its shade and enjoy the breeze from the Ouachita River, less than a mile from the back door. Still standing (below), the landmark has undergone extensive remodeling over the years and is now known as "Brown Oaks." Most of its once-extensive grounds are now a subdivision of modern North Malvern homes, as seen in the 2010 photograph below; the home was listed for sale.

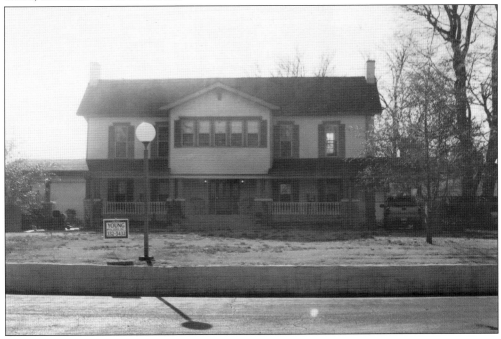

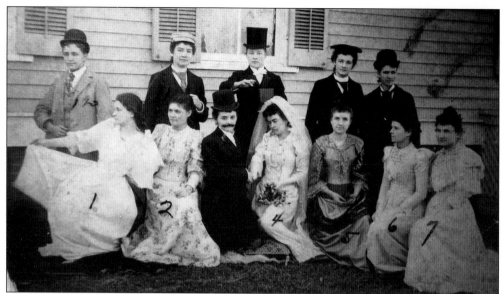

The "man-less" wedding was staged as a fund-raiser for the Malvern Women's Club around 1900. The event was held at the home of Josie Hill; she played the bride, while the groom was portrayed by Julia Colburn. Looking back over a century, it can easily be imagined what an effort it took for the women to keep a straight face, containing their laughter long enough to have this photograph made. (Courtesy HSC Historical Society.)

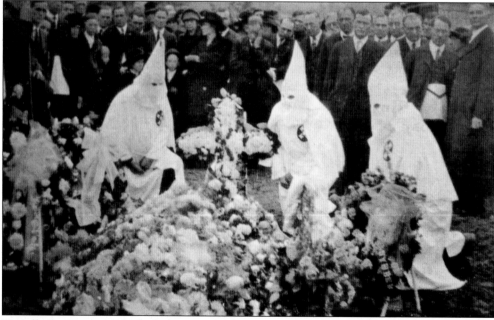

Not all white gowns were for happy occasions. At its peak in the mid-1920s, the Ku Klux Klan boasted more than a thousand members in Malvern and Hot Spring County. Among them were some of the city's and county's most respected business leaders and elected officials. Several clergymen also belonged. Four Malvern klansmen were photographed at Oak Ridge Cemetery paying their final respects at the funeral of a prominent businessman in March 1924. This striking image was taken by J. Childers, a local photographer. (Courtesy HSC Historical Society.)

The works and good deeds of some of Malvern's pioneers have been handed down in the form of unusually crafted artifacts. The Reverend J. M. Clem, part of a prominent Malvern family, served as the pastor of the Second Baptist Church between 1903 and 1906. An appreciative member of Reverend Clem's congregation built him this porch swing. Today the swing, a gift of Mary English, hangs on the porch of the 1876 pioneer cabin located behind the Hot Spring County Historical Museum. (Photograph by Ray Hanley.)

Some photographs survive but, as in the case of this 1890s image, the story is lost in time because nothing was recorded as to names or occasion. J. W. Bankston was a prominent Malvern photographer at the time that he positioned these well-dressed children in his studio.

"Here are the kids at play," wrote the mother of Cleo and Wayne Noble in 1911. Over the next century, many Malvern mothers would have written similar notes on photographs of their children to mail to friends and relatives. (Courtesy HSC Historical Society.)

Walter McMullin was born in 1871 and married Alice Benson in 1892, settling in Hot Spring County where the couple had their three children. Walter had the interesting dual occupations of farmer and singing teacher. He died in a Little Rock hospital in 1925 at the all-too-young age of 54 following an unsuccessful surgery. He is buried at the Brown Springs cemetery in Hot Springs County.

Born in East Bend, North Carolina, John Hiram Baker moved to Hot Spring County in 1872. Baker Hill—now North Malvern—was named after the Baker family. "Uncle Hiram," as he was known, truck farmed for many years. He would walk the streets of Malvern peddling his vegetables out of two baskets. He never married, but countless children had fond memories of their encounters with "Uncle Hiram."

Col. Enoch Houston Vance moved from the north to Malvern to practice law in the 1880s. Always dressed in a black coat, active in the Methodist church, and a Master Mason, Vance became a well-known trial lawyer. His grandson Vance Jernigan talked of the cigar always in his grandfather's mouth and how he loved to hitch a pair of sorrel horses to his surrey, load the family up, and drive to the Grigsby Ford of the Ouachita River. (Courtesy HSC Historical Society.)

Lydia Ashcraft was born in 1881 in Illinois to a father who had served in the Confederate army. She married John J. Ashcraft on Christmas day in 1897 at the age of 16 and would later settle on a farm in the Reyburn community of Hot Spring County. She posed here on the farm with one of her eight children, Beryl Jean, who had been born in 1913. Lydia would give birth to the mother of this book's authors in 1921 on the Reyburn farm.

John Jacob Ashcraft was born in Kentucky in 1872, and at the age of 27, he married 16-year-old Lydia Miller in 1897. Ashcraft supported his large family mainly through working on sawmill machinery across Arkansas and North Louisiana. He practiced photography as a hobby, capturing views of his family that often were printed on postcard stock. After a lengthy illness, John Ashcraft died in 1931 at his farm in the Reyburn community, in a house that still stands.

Tragedy struck the Ashcraft family in 1925 with the accidental death of 15-year-old son, Guy Ashcraft. The teenager, seen here not long before his death, had gone to work against his mother's wishes at the same sawmill as his father, John. He was walking along the top of a railroad carload of logs, when the cable broke, and Guy was crushed to death. John Ashcraft sued the lumber company, and in retaliation the company fired him.

Lydia Ashcraft, who became a widow in 1931 at the age of 50, never remarried. She lost the Reyburn farm after the death of her husband, when someone forged her signature and sold it out from under her. By 1949, she was living in a small, unpainted frame house on Fairview Street in Malvern. She was photographed in the yard of the house holding her new granddaughter Inez Marie Kernick. Ashcraft would suffer a stroke in mid-1951 and be bedfast for the last 15 years of her life; she died in 1966 and is buried in the historic Rockport Cemetery at Malvern.

George Holt raised his large family in the Reyburn community, supported with his skills as a farmer. Holt was a successful, well-known truck farmer in Hot Spring County, supplying produce to area grocery stores. Holt was photographed around 1940 with his family on their Reyburn farm. From left to right were daughters Lavern, Pauline, George, his wife, Viola, daughter Mary Bell, sons Haywood and Henry. (Courtesy Pauline Holt Reynolds of Malvern.)

Then as now, rural Arkansans enjoyed showing off their livestock. Albert Bauchman of Magnet Cove posed with his prized hog in this c. 1920 image. The porker grew to weigh approximately 950 pounds and was named Ohio. (Courtesy HSC Historical Society.)

Written on the back of the *c.* 1910 postcard is, "4th from the left, Alfred Bost." This evoked the authors' memories of an elderly man and his wife who ran a tiny neighborhood grocery store at the end of Fairview Street during their childhoods. A very much younger Alfred Bost posed for a mock battle with four other young men wielding axes, guns, and knives.

In May 1923, Malvern's first hospital was established by three local physicians—Dr. E. H. McCray, Dr. W. G. Hodges (pictured), and Dr. E. J. Bramlitt. Located on Second and Olive Streets in a converted house, the facility consisted of eight beds and one operating room, with a nurse in charge at all times. The Women's Missionary Society of First Baptist Church gave a linen shower for the opening of the hospital. Today the modern Hot Springs County Medical Center offers very fine hospital services to the community, which started with the pioneering efforts of a few area physicians more than eight decades ago.

The story of the American people is sometimes told on fabric. This Liberty Loan Honor Flag was awarded to Hot Spring County during World War I. In order to raise the money needed to fund the war effort, each state, county, or district was apportioned its share of the loan to be made based on population. When a state, county, or district had met its allotment, it was entitled to display its honor flag. It was a matter of civic pride to keep the honor flag flying regardless of the increasing amounts of the loans asked. The flag's three stripes signified that the county met all three loans asked of its citizens. According to the 1920 census, Hot Spring County had 3,864 residents, thus the amount of its loan would have been approximately $28,000.

A story of independence and work ethic could be said to have lined the face of Susanna Lawrence a century ago. The lady was blind but insisted upon earning her share of the family's income by working on a loom set up for her in the living room of the family home in the Gourd Neck community near Magnet Cove. (Courtesy James and Carolyn Batts.)

Abel G. Sullenberger was born in 1810, and his wife, Elizabeth, in 1817. The couple married in 1833 and eventually settled in Hot Spring County. Abel died at the age of 91 in 1901, outliving Elizabeth who had died in 1897. Today one of the major Malvern streets bears the Sullenberger name. (Courtesy HSC Historical Society.)

This one-room log cabin was built in 1868 by John Crockett Gibbs and his father, Harmon B. Gibbs. John brought his wife to the cabin on their wedding day, November 1, 1868. John was a farmer and also hauled freight from Hot Springs to Rockport, an area that then was a virtual wilderness. Named in 1873 and incorporated in 1876, Malvern was not yet a town when the Gibbs family came. Originally located on Walco Road near Malvern, the restored log cabin is now on the grounds of the Hot Spring County Museum

Originally a one-story dwelling, this house was built by Benjamin Berger and his wife, Carrie, in 1892 in the 300 block of East Third Street. Two years later, it was purchased by Jacob R. Boyle and his wife, Agnes. The second story was added in 1905, and in their larger home, the Boyles raised their children who would go on to make prominent citizens in the community. (Courtesy HSC Historical Museum.)

In this 1978 photograph, Stella Boyle Smith (left), her brother Ray Boyle, and sister Evelyn Boyle Bryan pose on the front porch of the house where they grew up. Stella Boyle Smith was a noted philanthropist, contributing to many Arkansas educational and medical institutions. Her wealth stemmed in part from land holdings in Woodruff and Arkansas counties. She died in 1994 at the age of 100, having left as a small part of her legacy her former home to serve as the county's historical museum. In the photograph at the top, the home was being moved to its current spot next to the Hot Spring County Library. (Courtesy HSC Historical Museum.)

Today the restored Boyle House is the home of the Hot Spring County Museum, dedicated to the preservation of history as it pertains to, in the words of director Janis West, "who we were—who we are—and who we will be." This treasure is filled to the brim with stories, photographs, and artifacts revealing the area's historical past. The museum brings history alive for generations of citizens, young and old year-round and is one of the finer local museums in Arkansas.

In some closing thoughts on having done a hometown history, it has been our privilege to have created this history of Malvern, Arkansas, and its people. It is filled with images of people and places that are both on the pages of this book and ingrained in our memories. We close with this photograph of the authors with their father next to the little unpainted house on Malvern's Fairview Street, our mother's shadow cast over us as she focused her little Brownie box camera around 1954.

www.arcadiapublishing.com

Discover books about the town where you grew up, the cities where your friends and families live, the town where your parents met, or even that retirement spot you've been dreaming about. Our Web site provides history lovers with exclusive deals, advanced notification about new titles, e-mail alerts of author events, and much more.

MADE IN THE USA

Arcadia Publishing, the leading local history publisher in the United States, is committed to making history accessible and meaningful through publishing books that celebrate and preserve the heritage of America's people and places. Consistent with our mission to preserve history on a local level, this book was printed in South Carolina on American-made paper and manufactured entirely in the United States.

Find Your Place in History.